ART FROM INTUITION

ART FROM INTUITION

OVERCOMING YOUR FEARS
AND OBSTACLES TO MAKING ART

DEAN NIMMER

Foreword by Gregory Amenoff
Chairman of Visual Arts Division,
Columbia University

WATSON-GUPTILL PUBLICATIONS/NEW YORK

This book is dedicated to my children, Christopher, Corey, and Lilly, and to my granddaughter Kaitlyn.

Senior Acquisitions Editor: Joy Aquilino
Editor: Cathy Hennessy
Production Manager: Alyn Evans

Cover design by Rodrigo Corral
Interior design by Rodrigo Corral Design / Jason Ramirez

Text copyright © 2008 by Dean Nimmer

First published in 2008 by Watson-Guptill Publications,
an imprint of the Crown Publishing Group,
a division of Random House,Inc.,New York
www.crownpublishing.com
www.watsonguptill.com

Library of Congress Cataloging-in-Publication Data

Nimmer, Dean.
 Art from intuition : overcoming your fears and obstacles to making art /
by Dean Nimmer; foreword by Gregory Amenoff.
 p. cm.
 ISBN-13: 978-0-8230-9750-0 (alk. paper)
 ISBN-10: 0-8230-9750-1 (alk. paper)
 1. Art--Technique. I. Title.
 N7430.5.N555 2008
 701'.15--dc22

 2007042541

Printed in China
First printing, 2008

3 4 5 6 7 8 / 15 14 13 12 11 10

Contents

Foreword

In-tu-i-tion: 1.) last night's dream + impulsive idea + weird uncle + too much coffee + mystical vision + unrequited desire = Intuition

This faux equation may be as close as one can get to defining the creative jump that is called intuition. It would seem plain wrong-headed in the foreword to a book on inventiveness to use a dictionary definition for such an elusive concept. Intuition, after all, is a notion that defies rationality, yet the intuitive process is not without its own logic. In fact, I would argue that works of art offer the viewer a portal that opens directly into the intuitive process of the artist. Although the "art experience" is multifaceted, it depends to a large measure on the intuitive "space" shared by the viewer and the creator. This book relies on imagination to help readers find the freedom to exercise their own innate intuitive spirit and to enter into the intuitive space of others.

For many, the notion of the artist's creative process is shaped by the Hollywood image of the isolated, mad genius stabbing the air for ideas and then suddenly realizing them, fully formed, on a canvas, a piece of stone, or in brisk musical notation. We all know that films can't help but stereotype their subjects, and these often romanticized characterizations seem to substitute affectations for what is really a complex and amazing process. Let me suggest instead a more realistic version of the artist in the midst of a creative process.

The artist enters the studio, armed with an idea for a painting (or sculpture, song, etc.). Often, the idea appears to the inner eye *somewhat* formed, but until it is physically manifest, its outline is, at best, a bit cloudy. Marks are made, colors are applied, and the object is set in motion. The creative spark is

now lit, but the fire needs tending. It is *instinct* and the willingness to trust it that now come into play. As counterintuitive as it seems, intuition involves countless subjective considerations and small judgments. Judgments? Yes! Not rational judgments or evaluations, but intuitive decisions—each one propelling the work of art beyond its limits. The artist must then trust (or distrust) those leaps, only to leap again and again, possibly in different and even contradictory directions. Imagine Jackson Pollock moving and dancing with the paint, using his eye and his intuition to direct his hand in order to bring a new world into clear view. The creative spark allowed him to begin—to see something that he felt needed to be rendered visible—but intuition and the audacity to trust it propelled the paintings into greatness and, finally, into history.

But intuition does not necessarily live only in those almost trancelike moments of creativity; it also comes into play upon reevaluation. The day after, perhaps things don't look so rosy and magical; decisions made earlier might look weak or flawed. Then the artist must again rely on his or her intuition to adjust, to destroy, and to rebuild—until the final marks are made and the image is allowed to emerge from those countless small judgments and take on a life of its own.

Artists must intuit, and they must trust their instincts, thereby taking a huge risk. That risk can result in outright failure at worst, or it may yield the artist a grand success, but without the development of the intuitive self and a willingness to embrace and finally trust it, little of consequence can be accomplished. Having said that, the insights in this book are meant to speak to an audience much more broad and varied than the world populated by artists. The projects within these pages can speak to all of us—coaxing us to discard our fears of creativity and replace them with faith in an intuitive, inventive process—one that can transform the mundane into the remarkable and the blank canvas into something of great personal value.

Gregory Amenoff
New York City 2006

Gregory Amenoff is Chairman of the Visual Arts Division and the Eve and Herman Gelman Professor of Visual Art at Columbia University in New York City. He served as President of the National Academy of Design from 2001 to 2005 and is currently Curator Governor of the Cue Art Foundation.

Tramontone, oil on canvas, by Gregory Amenoff. Courtesy of the Metropolitan Museum of Art.

Introduction

Art from Intuition is designed to help you free your creativity so that you can fully engage in making art. Its underlying philosophy is that creative intuition is an instinct, a kind of inner compass or "sixth sense," that helps guide an artist's work. Everyone has his or her own natural intuition, which is a key asset in creating art. By letting go of preconceived ideas about art-making and tapping into this unique reserve of creative energy, you can explore new horizons in your work.

This book is made up of a series of hands-on projects (each comprising one or more exercises) designed to help you advance from thinking about making art to drawing and painting whenever you have the urge. Also listed under each project is a section called "Other Exercises to Try," which will give you ideas for expanding on the exercises. The projects in this book are designed to progress logically from simpler, more accessible techniques to those that are more complex and varied. However, no restrictions of talent, skills, or prior art experience should stand in the way of choosing an exercise that has immediate appeal. You do not have to do the projects in order, but rather should allow yourself freedom to work on any that pique your curiosity.

The exercises are intended to stimulate and nurture your intuition and to allow it to be your trusted guide. They come directly from my thirty-five years of teaching experience and from my personal practice as an artist. I've used these same exercises to instruct artists at all levels—from the most timid novices to those with years of professional experience. The ultimate goal of the exercises is to help artists free themselves from the psychological roadblocks that inhibit creativity, and to open up a myriad of new and exciting possibilities for making art.

Unlike other "how-to" books, *Art from Intuition* is not trying to teach you to paint a still life using a particular technique or to draw an image that looks like the one in the book. Instead, the exercises describe how to follow your instincts and intuition and see where that inspiration takes you. Most of the exercises in the book showcase a variety of art my drawing and painting students have created over the years while doing those same exercises. This illustrates the point that when you follow your intuition, you are more likely to create a picture that fits your own artistic personality rather than simply reproduce a picture from a book.

Art from Intuition also includes quotes at the end of each chapter by contemporary artists who comment on the use of intuition in their own practice. Each quote is accompanied by a work by the particular artist. However, these works do not represent the style of intuition painting that I am encouraging in my book; rather, they exemplify the diversity that can be achieved by using your intuition in creating art.

Although most of the exercises in this book tend to result in abstract images, all the projects and exercises can be applied to any style of art. The connection with abstract art derives from the need to tap into the subjective aspect of one's intuition and to develop something visual out of pure imagination. The goal is not necessarily to make studies in abstract art, but rather to use these freer, less restricted methods to enhance creative spontaneity and to increase the pleasure you experience during the process of making art.

The idea for this book first came to me in 1995 while working on a project to create 1,000 drawings in a single year. I quickly realized that to accomplish this goal, I was going to have to change several bad habits that had become ingrained in my painting process. Among these habits were: becoming fixated on one painting for long periods of time; trying to determine whether each piece I made was "good" before I went on to the next; sticking to the same palette or medium for too long; and holding steadfastly to the notion that my work should have a consistency or "style" that would give it an overall identity. Over the course of completing the drawings, I discovered that all the ideas I held sacred were in fact holding me back from real discovery and new possibilities for my art. I came to understand that in order to avoid these pitfalls, it was much better to allow my instincts and intuition to show me the way, and to stop being so self-conscious.

I was inspired by the insights I gained through working on the 1,000 drawings, and I wanted to share this newfound knowledge with my students. So I began to develop drawing and painting exercises to encourage my students to tap into their own intuition and use it in the creative process. My students have responded very positively to these projects, and I've seen significant progress in the quality of their artwork as well. Most important to me is the fact that my students have become more enthusiastic about the process of making art and have gained a stronger resolve and dedication toward continuing with their work.

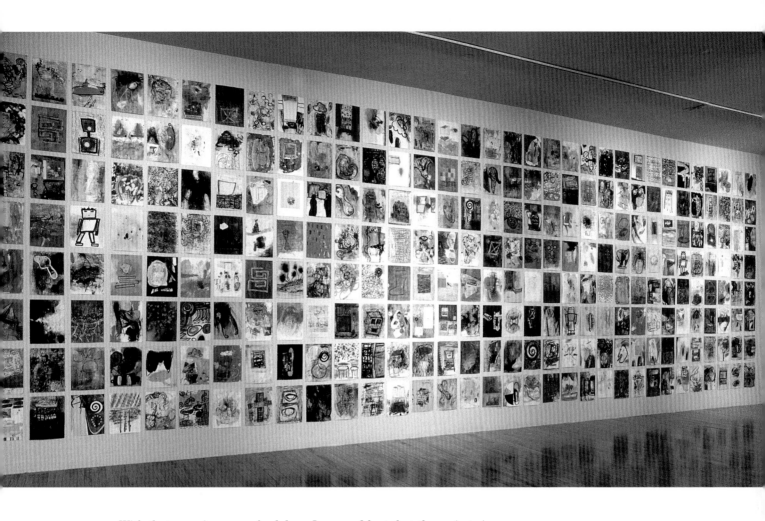

With that experience as a backdrop, I am confident that the projects in this book will motivate you to make art and to more deeply appreciate the value of your own instincts toward creativity. The challenge is clear: you don't get the benefits unless you actually do the work. I recommend that you dive into any of the exercises in this book without analyzing whether they fit your particular artistic goals or whether they are outside of your personal "comfort zone"—so just get going, and think about it later!

Installation of 308 Drawings,
mixed media, by Dean Nimmer.

Getting Ready:
There's No Time
Like the Present

CHAPTER ONE

The hardest task this book asks of you is probably to stop reading instructions and pondering what you'd like to make and actually get started painting and drawing. There is no better way to learn than by doing, so with this in mind, I have kept my advice and directions to a minimum. In this chapter, I offer bare-bones advice about the most essential tools and materials you'll need to have on hand, as well as practical tips and suggestions on how to set up a time and place to work.

What I can't really do for you is get you into the right frame of mind for making art. I can and will give you strategic advice about how to keep your art's momentum going—tips I've learned from my career as both a teacher and an artist. But you will have to commit yourself to actually making art and *doing* the projects in the book—just thinking about what it might be like won't cut it! My responsibility in this sticky situation is to be less like your art teacher and more like your sports coach on a mission—to "Pump you up"! Seriously, I want you to think of my instructions simply as strategic points given to someone who already knows what to do with a ball, a tennis racquet, or some paintbrushes. You have your own innate artistic intuition to guide you, but it's up to you to supply the *passion* to make things and the *hunger* to try out myriad possibilities in your art in order for it to succeed!

WHAT YOU'LL NEED

A Time and a Place

The two things that every artist needs are a time and a place to work. Understanding that we all have jobs to go to, children to tend, meals to make, houses to clean, it is still essential to carve out a time to make your art. This time could be in the evening, when everyone else is otherwise occupied or asleep; or you may be able to find a longer stretch of time on a weekend. Like anything else you love to do (meditate, exercise, play an instrument, etc.), you know you won't get to it unless you schedule it into your routine. In addition, art is an activity that requires uninterrupted time to concentrate on what you are doing. With this in mind, I recommend that you make out a weekly schedule with at least a two- to three-hour block of time you can devote solely to your art. Of course, that schedule needs to be flexible enough to accommodate unforeseen events, but it is important to make a commitment to spending time working and to stick with it.

The other important requirement is to establish a consistent place where you can do your artwork. There are really only a few things required for a home studio: privacy, adequate light (natural or artificial), a surface to work on, and enough room to step back and see what you're doing. Even these requirements can be defined creatively: you can use the kitchen table, a part of the attic or basement, or even a space set up in your garage. If your space has to serve dual functions, like the kitchen or dining room, use drop cloths to protect surfaces, and keep your materials in portable containers for easy storage. Even though you may not have the ideal space for making art, you can create a space that is yours, and that's the most important thing! You'll never get started making art if you use the excuse that you don't have the time or the space to do your work.

Essential Supplies

I don't want you to worry about ruining a costly piece of paper or wasting expensive paint when you are working on the projects in this book. To this end, I am recommending just a small number of low-cost items you'll need to have on hand. Unless you are a true beginner, most of the necessary tools can be found among the materials you are already using.

So before going to the art store to pick up the items listed below, check around for things you may already have in a box somewhere. In particular, look for half-dried tubes of paint, broken or unsharpened pencils, scruffy old erasers, and the like to use up before you go out to replace them. (Note that some exercises in this book, such as those under Simple Prints and Drawing with Smoke, require specific materials that are listed in the descriptions.)

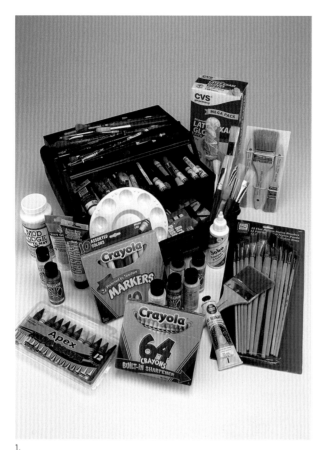

1.

2.

The following is a list of basic supplies you will need to get started:

→ 18 × 24 newsprint pad and a similar-sized pad of "drawing" paper, sometimes called "bond paper"

→ A simple sketchbook composed of a clipboard and 8½ × 11 copy paper

→ Soft and medium grades of compressed charcoal sticks and an inexpensive box of colored pastels

→ Wax crayons, cheap oil pastels, and black and assorted colors of felt-tipped markers

→ Assorted grades of graphite and charcoal pencils

→ White glue and school supply-type glue sticks

→ Simple stuff like pushpins, scissors, a utility knife, a ruler, a compass, and a container or tackle box for your art supplies

1–2. Basic art materials.

1.

The following is a list of useful materials that you can purchase at a grocery or hardware store, or that you may already have lying around your home:

→ Plastic wrap, parchment paper, and wax paper rolls
→ Styrofoam trays and plastic cups left over from food shopping
→ Tin or plastic cans (not glass jars) for holding water
→ Painter's tape (not masking tape)
→ Joint compound or wall spackle
→ Junk painting brushes and old cans of acrylic house paint from your basement
→ Your own photos, magazines, newspapers, etc., for use with collage
→ Interesting finds from the trash or from flea markets that can also be useful in collage or assemblage artworks

USING SKETCHBOOKS

There is no such thing as a "bad" drawing in a sketchbook! The primary value of the drawings and notes you put into your sketchbook is that they can inspire new ideas to work on without worrying about whether any particular drawing looks "good" or is a "finished" piece. In other words, it's important to feel comfortable with the casualness of your sketchbook, and not to feel intimidated by the notion that someone may look at it and see a poor rendering or a scribble they don't understand. With this in mind, your sketchbooks should contain only the simplest of drawings, such as plain, outlined contours that

are free of elaborate details and unnecessary embellishments of color, value, and texture. Think of your sketchbook as a practical tool that helps you bank your ideas and spontaneous flashes of inspiration so that you can use them for future reference. And, in order for your sketchbooks to function properly, you need to keep an open mind about the value of visual ideas that come to you without any forethought or planning. Your sketchbook can then be the place where anything goes and where you don't have to be overly concerned about what anything looks like. So I recommend that you start keeping a simple sketchbook from the beginning, as an ongoing part of your art-making.

Types of Sketchbooks

Sketchbooks are sold commercially in many different forms and sizes. There are fancy (expensive) leather or "leather-like" bound books, spiral-bound notebooks, and glue-bound sketchpads you can buy in any art supply store. In general, though, I feel that all these sketchbook formats raise annoying issues that get it the way of their main purpose. For example, the problem with leather-bound sketchbooks is that they can have a negative effect on an artist's spontaneity by making you think that a sketch has to be good enough for this fancy, expensive book. And, like its spiral-bound counterpart, it can be difficult to remove sketches from leather books, and the laced or wire bindings are often a nuisance that gets in your way when drawing in them. The problem with loose-bound sketchpads is that the paper is unnecessarily expensive.

Instead of commercial art store sketchbooks, I recommend that you use simple, blank, 8½ × 11 copy paper on a business clipboard or blank 5 × 7 note cards. I prefer the copy paper or the note cards because they are cheap, available anywhere, easy to use, and there's no guilt in tossing away any pages if you don't happen to like a particular sketch.

2.

2. Sample sketchbooks, including simple clipboard.

The first step when starting your own sketchbook is to decide what you want to do with it and how you can make it serve your artistic needs.

Here are some suggestions for ways to make your sketchbook most useful:

→ Plan on a regular routine of sketching and commit to it. For example, you may want to sketch at a particular time of day on specific days of the week that you can keep free for this purpose.

→ Think of every drawing in your sketchbook as being disposable. If you wouldn't dare erase or scribble over drawings in your sketchbook, then those drawings are not serving the purpose for which they were intended.

→ Work quickly (without thinking) to make on-the-spot records of subjects that interest you (e.g., objects, still lifes, landscapes).

→ Sketch out preliminary drawings for future paintings, collages, prints, or other projects.

→ Make handwritten notes in your sketchbook that help you record details and ideas that are too difficult to draw.

→ Use your sketchbook to make spontaneous drawings (doodles) that have no predetermined subject.

→ Record ideas in your sketchbook that come to you in a dream or just seem to appear out of the blue.

→ Use your sketchbook to keep materials like color swatches, texture samples, photographs, or collage materials for future projects.

Your sketchbook can also be a good place to write down notes to yourself about any topics that relate to your art, or to your creative process. For example, writing down self-critiques about what you think of your own work (what you like about it and what you don't like about it) or noting comments others have made about your art that may be useful to think about. In terms of your art-making process, you may want to note how well you are doing at using your intuition, working spontaneously, keeping up with your schedule, and so on.

1. Sketchbook page with handwritten notes, student work, pencil on paper.
2–3. Sketches (top) by Yuriko Yamaguchi for her large-scale wall sculpture *Metamorphosis* (bottom).

1.

2.

3.

BUILDING UP AND KEEPING PORTFOLIOS

I strongly recommend that you keep much of the work you create from the exercises in this book in three separate portfolios entitled "Like," "Dislike," and "TBC" (To Be Continued). The purpose of the Like and Dislike portfolios is to keep examples of work you consider to be your best and worst attempts at a particular exercise. The reason for keeping both of these so-called "good" and "bad" examples is the valuable knowledge you can gain by comparing these two extremes. As often happens upon reflection, the drawing you thought was a mess the other day may turn out to be one of the more intriguing or innovative pieces in your portfolio—go figure! The most important reason to have these polar-opposite portfolios is that they will give you a critical perspective on your work that is lost when you only keep those things that you like. It's also true that you stand to learn more from the pieces you don't like—it's better if you actually *hate* them—than you learn from those works that simply affirm what you already know: "I like it because it looks good."

The TBC portfolio contains examples of sketches, drawings, or paintings you may want to continue developing at another time or use to inspire other work along the same lines. Another possibility for this portfolio is to use portions of these works (interesting sections) in future collages and assemblage artworks. Remember, too, that these portfolios are a fascinating record of your ideas and development as an artist. All the work you keep there—the good, the bad, and the ugly—is an important part of your creative expression.

Mind you, I'm not just pushing recycling here. I'm simply saying that you shouldn't be so quick to throw away potentially valuable resources that might feed your imagination and provide ideas for future work. This portfolio can also help you answer the oft-asked question, "What do I want to work on today?" I believe that having the Like, Don't Like, and TBC portfolios ready to go as soon as you begin working from this book is as important as any of the materials you'll need to have on hand from the start.

Physically, these portfolios should be large enough (in terms of length, width, and depth) to hold twenty to thirty examples of your work. You can construct these portfolios yourself by getting two pieces of plain cardboard or foamcore measuring about 24 × 30 and using duct tape to put them together; or buy the cheapest ones you can find at an art store that are big enough to hold most of your work.

The Top 10 Obstacles to Making Art

Once you begin working from the exercises in this book, you are likely to encounter some typical blocks and fears that will challenge your commitment to continue. Many of these same issues affect all artists across the spectrum, regardless of experience or talent, and it is important to identify some of the major ones. This list is meant to expose the false basis for the fears that can stop you from working and to provide you with ways to overcome these obstacles when they do get in your way.

The fear of art! by Gary Hallgren.

Obstacle 10. I can't draw a straight line!
Straight lines are overrated and are not a requirement for making art—never have been, never will be! But if you need to draw a straight line, feel free to use a ruler.

Obstacle 9. Don't I need to study art to be able to make art?
Your greatest asset is your own *desire* to make art. Although studying techniques and art history are stimulating and encouraging to the art-making process, they do not represent a "toll gate" that you must pass through in order to be qualified to paint and draw.

Obstacle 8. I'm too old (or too inexperienced) to start making art.
There is no such thing as an age restriction for making art. Now is the best time to take the initiative and to stop waiting for the right time to come along. Young or old, experienced or not, the capacity to make art has always been a part of you, and you simply need to give yourself permission to go ahead and start, at whatever time in your life the urge hits you.

Obstacle 7. I can't make things look "real."
If the point of art were to faithfully reproduce everything we see, that ambition would have ended with the invention of the camera. Both realism and abstraction originate from a subjective vision in the mind's eye that has no literal reality to it. If you don't believe this, try taking a bite out of one of Cézanne's apples!

Obstacle 6. No one would want to buy my art.

The fact that you may not have success selling your art should not be a factor in deciding whether to continue creating it. As a practical matter, very few artists actually make a living from selling their art. Think about the percentage of successful professional golfers or tennis players as compared with the vast numbers of people who play those same sports for pleasure. Also keep in mind that failing to sell your art is not a gauge of your success or failure as an artist. The cliché of the "starving artist" is built on the false premise that the purpose of making art is necessarily to sell that art. In fact, the purpose of making art has much more to do with satisfying an artist's passion to create than with selling the product he or she created.

Obstacle 5. My friends/family think that making art is a waste of time.

The fact that someone you know may view painting or drawing as impractical or self-indulgent needn't have a bearing on your choice to make art. The best way to combat negative attitudes is to simply ignore them and to continue making art with all the passion and dedication that you have for this creative process. Don't give up this gift to satisfy someone else's need to be a control freak!

Obstacle 4. My art looks like a kid made it.

Picasso said that it took him ten years to learn how to paint like a master and the rest of his life to learn how to paint like a child. The point he was making was that he deeply appreciated how children are so naturally in touch with their creative spirits and able to paint and draw with uninhibited abandon for the sheer joy of making something. So if someone tells you that your art looks like a child made it, just say, "Thank you for the encouragement!"

Obstacle 3. I have no time to make art.

If you think you don't have enough time to make art, you'll never get around to doing it. Like many things that are good for your body and soul (exercise, yoga, meditation, etc.), you obviously don't derive any benefit if you don't make time to go to the gym, take the class, or go and make the art.

Obstacle 2. I've never considered myself to be an "artist."

Being an artist is not necessarily about being a member of an exclusive club. All too often, the urge to create is stifled because of the prestige or privilege associated with the word "artist." The fact is that there are absolutely no prerequisites for making art, or even for thinking of oneself as an artist—including talent, art degrees, gallery shows, or the desire to find fame and fortune in New York City. The only real requirement is that you make art, and then by definition you are an artist.

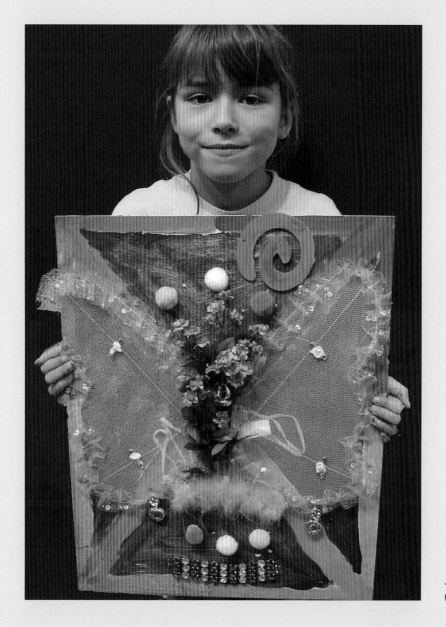

Young artist Aryn Banas with her collage.

1 Obstacle 1. I don't think that the things that I make are any "good." "Good" is a purely subjective concept. If making art feels good to you, then that experience is good! And if the drawings and paintings that you make please you, then that pleasure is yours to enjoy. It's essential, although not always easy, to set aside the judgment of others and focus on the satisfaction and personal meaning that you derive from creating your own art. In the end, the best defense against all of your personal "fear factors" is to persist regardless of the barrage of uncertainties that you face as an artist.

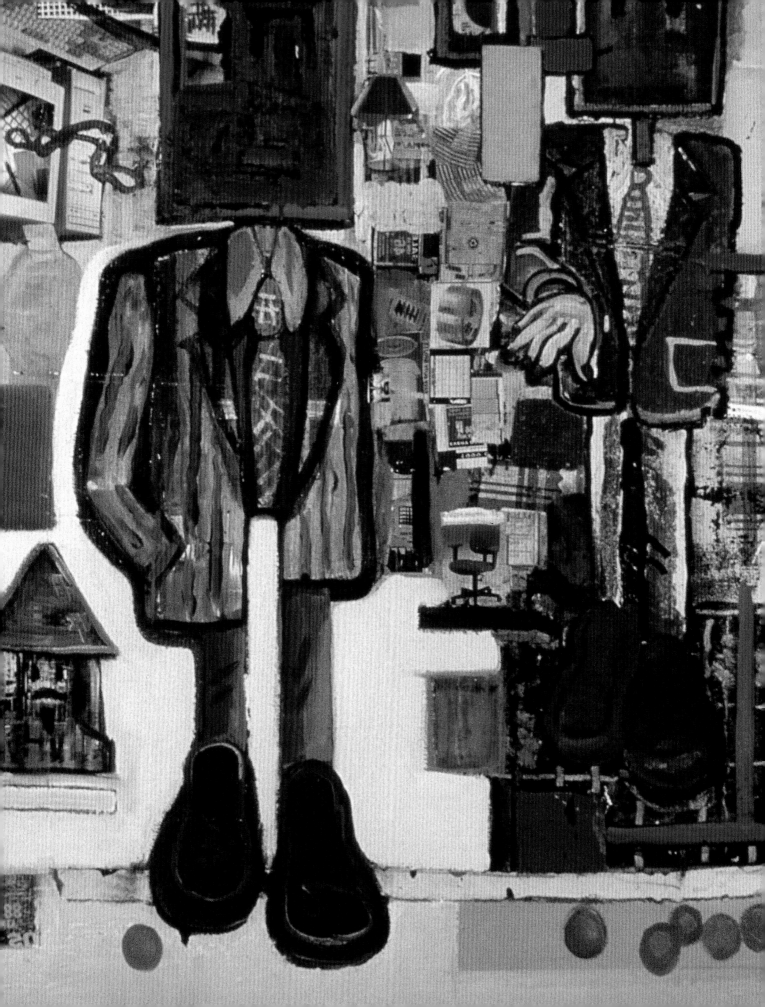

Artists on Intuition "Art created through an intuitive process seems more raw and truthful than a work by me that is contrived through hard reasoning and pre-planning. The thing I love about using my intuition to paint is that the ideas are constantly flowing through me like a high-pressure water pipe, and when the brushes come out, I have seemingly limitless possibilities ready to be tapped into." Stuart Diamond

Opposite page: *Fashionable Management*, mixed media, oil on canvas, by Stuart Diamond.

Stick With It!
THE GET READY CHECKIST

The "Stick With It!" tips that appear at the end of each chapter are designed to offer helpful hints and strategies on keeping yourself motivated to make art. Here we begin with a list of things to remember to get the maximum benefits out of this book.

○ Set up a place where you can make your artwork.

○ Establish a time to work, and stick to a weekly schedule of making art.

○ Begin working from this book with any exercise that strikes you as "interesting."

○ Don't worry about your skills or techniques or how much you know about art—just get into making something.

○ Start the process of using your sketchbook to record ideas and thoughts for your work.

○ Save examples of your work in the Like, Dislike, and TBC portfolios, starting with the very first projects you do.

○ Don't think—do!

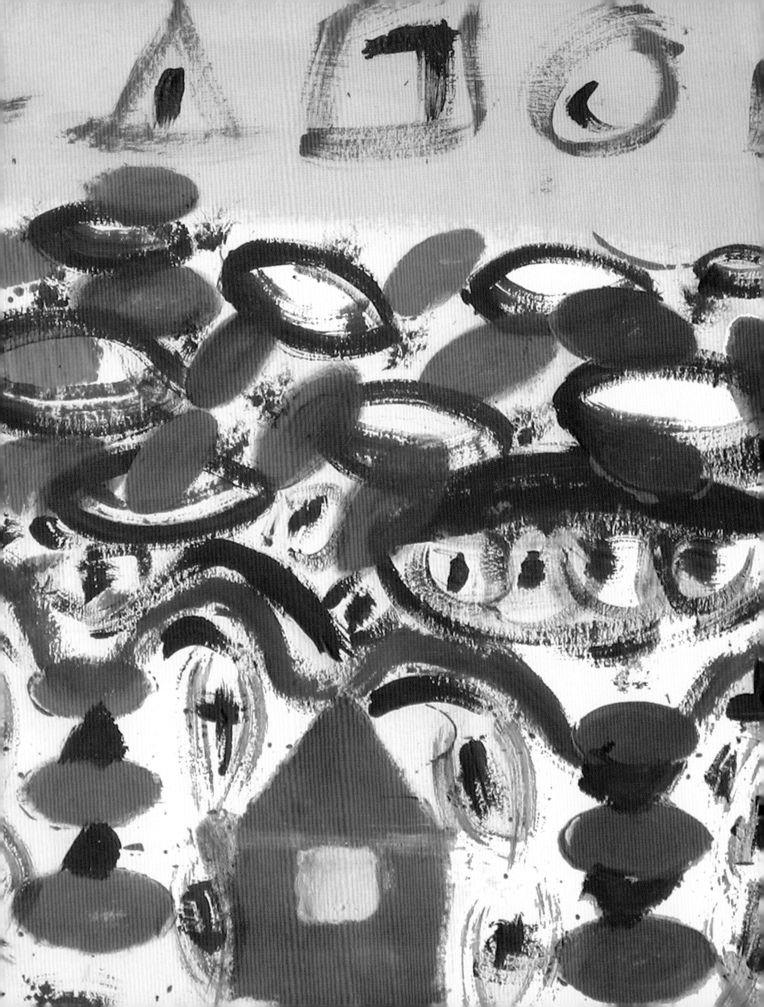

Child's Play: Reawakening the Spirit of Intuition

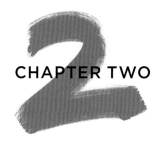

CHAPTER TWO

Remember when you were three or four years old and you would just scribble or smear paint around for the fun of it? At this time in your life, you were totally absorbed in the creative process, and you never gave a thought to what your paintings looked like or what it was that you were trying to say or express. As we move along in life, we tend to lose this sense of play and spontaneity that we had so naturally as young children. Here's a story that illustrates this point. An art teacher arrives at a friend's house for dinner and is introduced to his host's kindergartener. The little girl asks the guest, "What do you do?" He replies, "I teach art students to paint and draw." Looking confused, the little girl says, "Why? Did they forget?" Indeed, sometimes we do forget that we were born with powerful instincts to create and that those instincts can get trampled along the way by all the adult responsibilities and baggage that come with age and experience.

In this chapter, I am asking you to revisit those basic creative passions that were so strong in your childhood by sticking your fingers in paint and playing for the pure pleasure of the process. If you can suspend your inhibitions about acting like a kid for a few hours, the exercises in this chapter will help you find the roots of your creative intuition and inspire a renewed sense of excitement and adventure in your art-making.

ACTION PAINTING:
SPONTANEOUS CREATIVITY FOR PURE PLEASURE

Action painting is just what the name suggests: painting with pure abandon, dripping and spilling colors all over the place with no particular idea or plan in mind.

In the 1950s, Jackson Pollock, Willem de Kooning, and other abstract expressionist painters introduced action painting to the art world. However, long before that (probably since the advent of liquid paint), generations of young children practiced action painting. It makes sense that children would be the first to see how much fun it is to toss and smear paint around without wondering if what they were making was somehow great art. The fact that the abstract expressionists made this kind of child's play into an art form gives us adults a great excuse to play with paint, color, and texture just to see what comes out in the process.

One of the unique things about action painting is that the resulting pictures are a visual record of the artist's "dance" that created the painting in the first place. Action painting emphasizes the dynamics of the painting process with a focus on movement, gesture, and free-form play. This approach is a good place to start using your intuition because it allows you to use materials freely and to explore movement, spontaneity, and dynamic change without exerting overt control over the painting process. Action painting can involve your whole body—not just your hands—and allow you to use new tools and movements to make a work of art.

Because you want to maximize your use of intuition in these exercises, you will need to prepare to set aside any vestiges of technical control and critical judgment that might get in the way of making this experience as spontaneous and free-flowing as possible. The ideal frame of mind for action painting is to recall what it was like as a child to stick your fingers into paint and take pleasure in pushing it around on a piece of paper. Action painting is also fun to do with a partner (particularly a child) or a group of friends, since it is so user-friendly and engaging.

Materials

- → Newsprint or butcher paper that is 18 × 24 or larger
- → Several brushes—the bigger the better
- → Liquid acrylic or tempera paints or cans of used latex paint from your basement
- → India or Sumi ink
- → Small cups or plastic containers (for water and paint)
- → Squeegee, broad putty knives, sponges, and rags
- → Rubber gloves
- → Personal materials of your choice

Exercise 1. Let the Paint Splatter and Drip

Before starting, make sure you have a large area available, and put down a drop cloth or newspapers to protect the floor or table surface. I recommend using inexpensive papers like newsprint or butcher paper to catch your action painting so that you do not worry too much about wasting materials on paintings that you may or may not want to keep. It's important to let the process be spontaneous, with a lot of energy and without thinking about what you are making. Like many of the exercises in this book, you don't really need step-by-step instructions to engage in this intuitive process—just begin and see where it goes.

Action painting is nothing more than letting the paint do what it wants to do with a little help from you. The first thing to try might be the loosest form of action painting, where you begin by simply soaking a brush with paint and dripping and splashing paint onto your paper or canvas. Let the paint splatter and drip as you make bold, impromptu gestures, or change to more subtle patterns of movement to see what kinds of marks those gestures create.

Try using brushes of different sizes and paints of different colors, and let your marks merge together on the canvas. The first few times you try action painting should be purely experimental, and don't expect that a predicable picture will take form from this process. The important thing to remember is that unpredictability is what you are after, so you can revel in the pure enjoyment of playing with the paint.

Begin to experiment with different approaches: Try flinging paint off the brush to create explosive splatters, dripping paint from different heights, or pouring paint of different thicknesses (diluted with various amounts of water) onto the canvas at the same time.

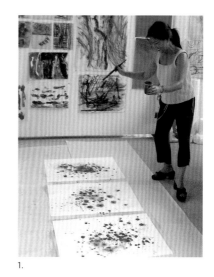

1.

1. Drip and pour action painting process, executed by Suk Shuglie.
2. Drip and pour composition, acrylic on paper.
3. Spontaneous gesture composition, ink on paper, by Claire Noonan.

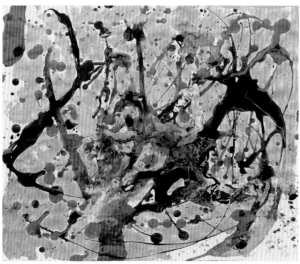

2.

3.

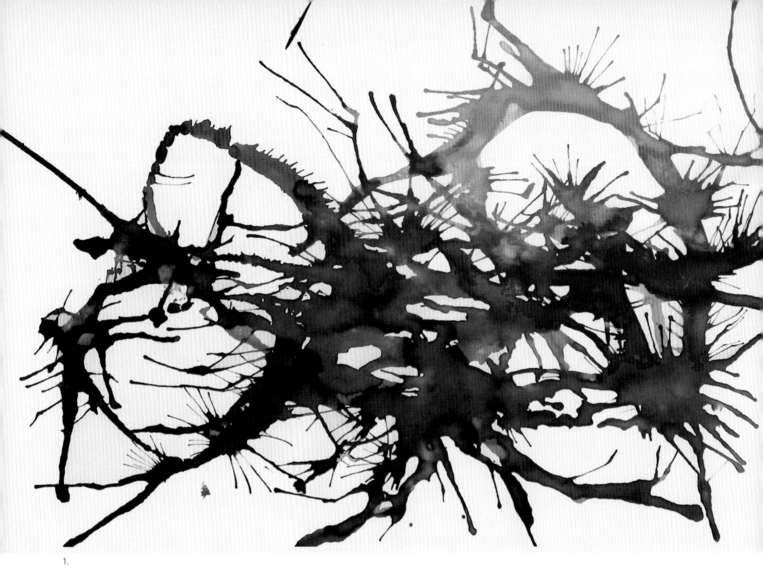

1.

1. Action painting made using a straw, acrylic on paper.
2. Finger painting combined with drip and pour technique, acrylic on paper.

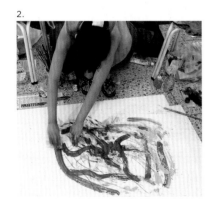

2.

Exercise 2. Straws Are Not Just for Soda

A variation on the dip technique is the idea of blowing paint around with a straw. Here, too, there is little need for directions—you did this stuff as a kid. The process is simply to make puddles of paint on your paper and then blow those puddles around with your straw. From there it's up to you to see where your composition will go. You can change colors and add more or less water to your paint to get different effects, as well as allowing one layer of paint to dry and then putting another layer on top. You'll be surprised by the variety of compositional ideas that will come out of this process.

Exercise 3. New Uses for Common Objects

In this exercise, you spread the paint directly onto the paper or canvas using a variety of non-art tools like a dishwashing sponge, a window squeegee, a putty knife, or anything else that's lying around the house. You can also find things like stones, sticks, and branches in your backyard that may make some interesting marks when you dip them in paint. Using these unusual tools, you can pull or push the paint around spontaneously to make textures, shapes, and patterns as you did in the preceding exercises.

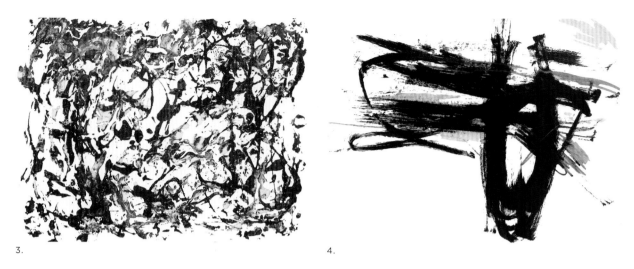

3.

4.

Exercise 4. Finger Painting Is Fun

Of course you remember finger painting? Now's your chance to try it again. No explanation needed here, either—you simply stick your fingers in paint and drag it around until you see a pattern you like. You can also combine techniques by pouring and dripping liquid paint while scratching it back into the surface of the painting with simple gestures that move back and forth, up and down, and side to side.

3. Action painting using paint applied directly from the tube, acrylic on paper.
4. Spontaneous, two-minute brush painting, acrylic on paper.
5. Layered hand- and finger-paint composition, tempera on paper.

5.

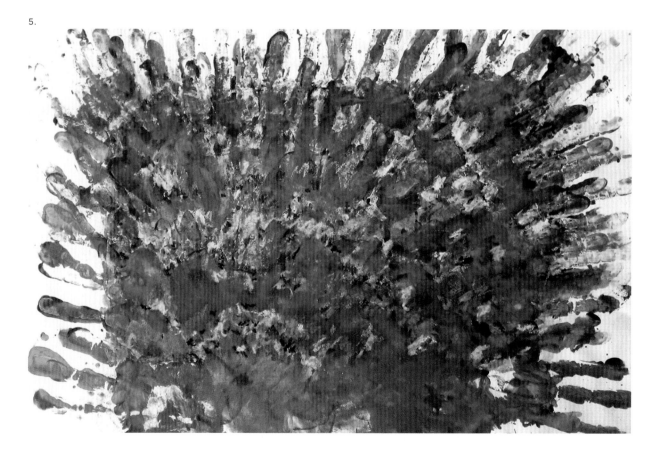

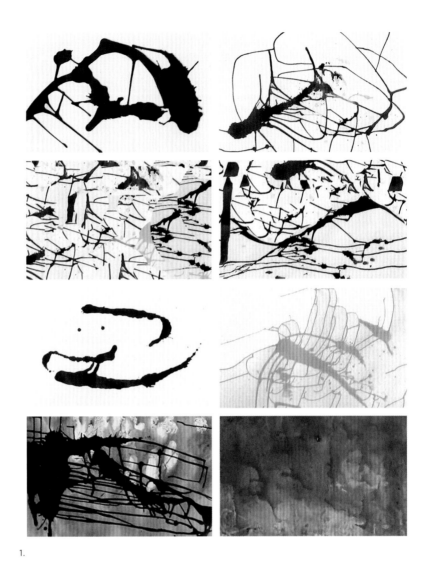

1. Display of different methods of action painting, mixed media.

1.

Exercise 5. Try It Fast or Try It Slow

Once you've become comfortable with different kinds of actions, begin a series of paintings that record different types of movement, speed, and energy. Consider limiting yourself to one or two tools or processes, limiting your color palette, and putting a time restriction on each painting. Now that you have a feel for how the paint spreads and drips, you can try some compositions that require some degree of control, like the straw-blown ink compositions above.

Exercise 6. Painting on a Wet Surface

Another action painting method is to prewet a heavy piece of 80-lb. to 140-lb. watercolor or printmaking paper by misting it with a plant sprayer or soaking it for a few minutes in a tub of water. Then you can apply paint or inks directly onto the wet paper surface to achieve unique depth and richness of color that are different from those achieved using dry-surfaced paper or canvas.

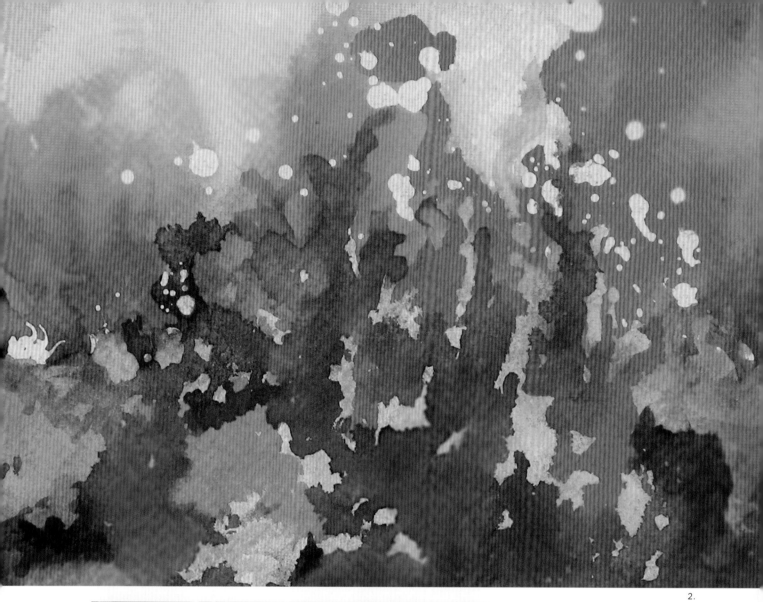

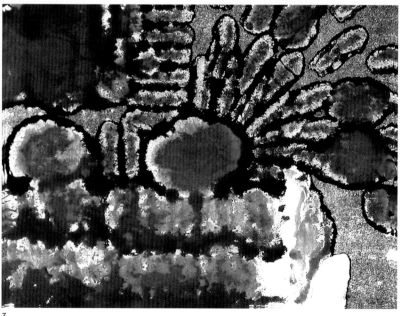

3.

2. Soaked paper composition, watercolor on paper.

3. Soaked paper and ink composition, ink on paper.

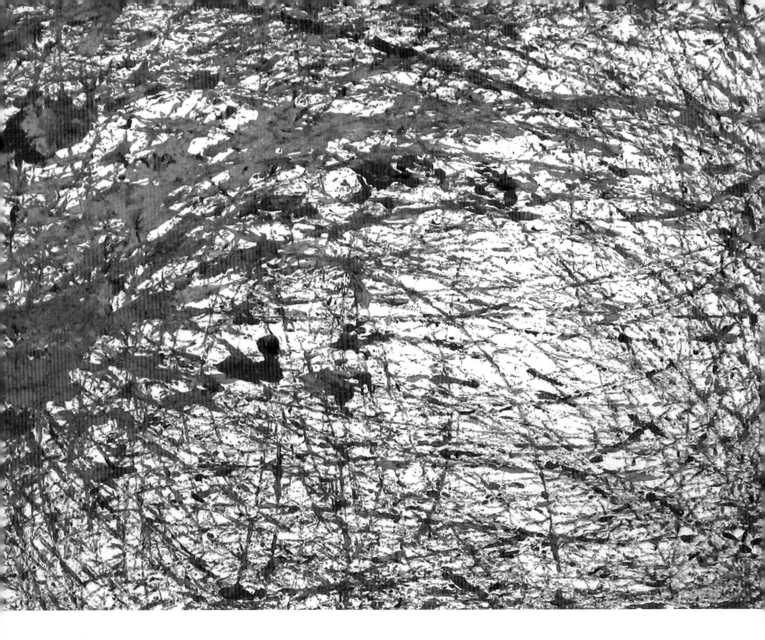

Other Exercises to Try

→ Start with an initial spontaneous action painting and then work back into that composition to form a new idea or develop a suggested theme.

→ Try "handicapping" yourself while you make an action painting by using only your opposite hand, using your feet, attaching your brushes to long poles, etc.

→ Try coating marbles in paint and letting them roll over the canvas to form random compositions.

→ Toss dry spaghetti or rice dipped in paint against the surface of the paper to achieve unusual textural effects.

→ Use a strong fan or hairdryer to blow liquid paint around on the canvas.

Don't forget to select examples from these exercises to put into your Like, Dislike, and TBC portfolios, and work on ideas in your sketchbook for future reference!

PAINTING TO MUSIC:
RESPONDING TO WHAT YOU HEAR
RATHER THAN WHAT YOU SEE

The next exercises are a kind of action painting that is inspired by music or raw, natural sounds. Many, if not most, artists have music on in the background while they are painting or drawing because there is a natural rapport between these two art forms. In certain forms of improvisational music, like jazz, the musician and visual artist are both relying heavily on their sense of intuition to guide them. The process of improvisation is more apparent in music than in visual art because you can usually hear the experimentation in the music, but you can't always see when an artist is improvising rather than following a predetermined plan. During some of my lectures, I've demonstrated that it is just as reasonable to describe a painting in vocalized sounds—humming, whistling, yelping, gurgling, etc.—as it may be to describe a piece of art in conventional language, but I may be quite alone in that assertion.

My interest in the relationship between art and music led me to devise a series of exercises that explore the connection between music and painting. As with the other exercises in this book, the process is pure fun, so be sure that no one is watching you paint, unless you want them to join in too.

Opposite page: Action painting made by using marbles dipped in paint and rolling them over on the drawing, acrylic on paper.

Materials

→ Newsprint or other inexpensive drawing paper
→ Acrylic, tempera, or other water-based paints
→ Paintbrushes (assorted sizes)
→ Charcoal or pastels
→ Markers or crayons
→ Radio, CD player, iPod, or boom box
→ Recordings of your selected music
→ Blindfold (optional)
→ Personal materials of your choice

Exercise 1. Painting to Music Blindfolded

Before you start this process, you may want to make a special CD of music that you think will be fun for painting and drawing. Consider different musical moods, like the drama of classical, the rhythmic complexity of jazz, the raw energy of rock 'n' roll, and the relentless pulsations of rap or techno. The goal is to let the music take over as you orchestrate your marks and movements to the sounds you hear. If you don't have a way to record your own sounds (or just don't feel like taking the time to do so), play any CDs that you want or tune into random radio stations for five to ten minutes each, and then switch the station.

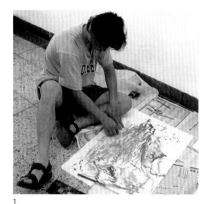

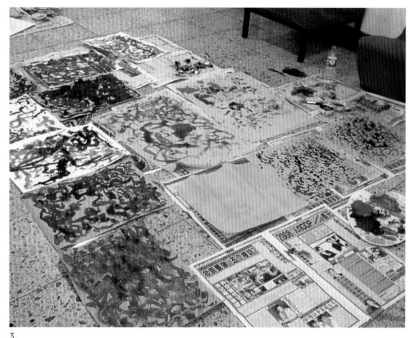

1. Blindfolded student paints to music, pastel and watercolor on paper.
2. Student keeps the beat while drip painting.
3. Various compositions made painting to music in a one-hour time span, mixed media on paper.

When setting up for this project, make sure that you have all your materials laid out in advance, and near enough so that you could find them easily if you were working blindfolded. Also, spread out plenty of newspapers or a drop cloth so that you don't have to worry about the mess you are making. Set up your music player so that you can start and stop it whenever you feel the need. Before beginning to paint, try turning on some of your prerecorded music and just listen to the sounds you hear. Listening to your music in the context of this exercise is a bit different than listening to music strictly for pleasure. In this context, you are hearing sounds selectively—listening for the highs and lows, the beats and rhythms, the energies and nuances that create a mood or feeling. This type of listening is an important warm-up for this exercise, which will help you focus your movements and marks in direct response to the sounds you hear. I also recommend that you wear a blindfold, close your eyes, or look away from your paper during this project because it helps you to concentrate on the sounds of the music rather than focusing on the picture you're making. If you are constantly looking at the painting, you are going to try to control what it looks like, and that tendency is going to conflict with your intuition and spontaneity. Once you are ready to go, start the music, put on a blindfold or close your eyes, and just start to paint or draw. You should continue this exercise for at least an hour at a time without stopping to look at each piece that you make—save that for later. Keep in mind that the individual pictures you make from this kind of experiment are not intended to be finished pieces; rather, they are works in progress, and as such, are best suited to be part of your TBC portfolio.

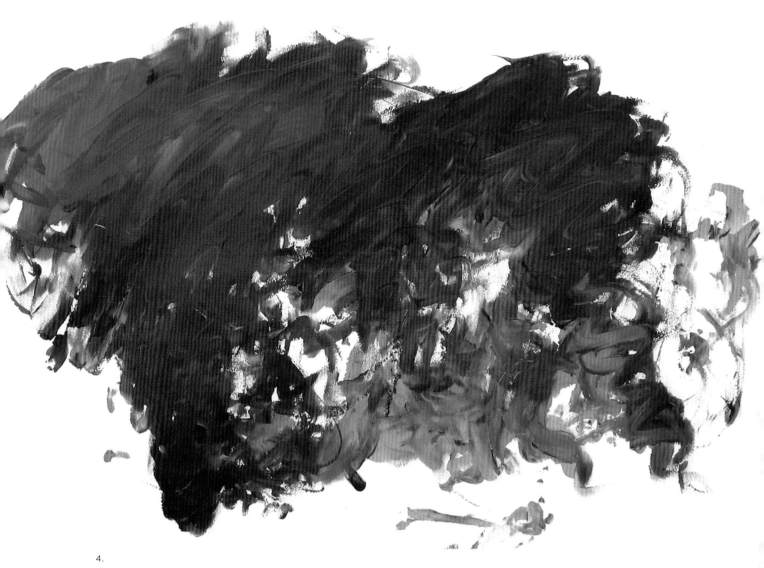

4.

5.

4. Finger painting to music, tempera on paper.

5. Blind gesture painting to music, pastel on paper.

Exercise 2. Elaborating on What You Hear

OK, let's say you can peek at your paper while working on the next batch of sketches. I still want you to respond intuitively and automatically to the music and let your marks and forms take shape based on what you hear and how the music makes you feel. My concern is that looking at your paper brings up the difficult challenge of maintaining your spontaneity without second-guessing every mark you make on the paper. But that's also the point of this exercise—so get used to it!

There is no universal way (or "right way") to visually interpret what you hear in music, so you can be sure that your pictures are likely to be quite different from those made by anyone else who tries this same technique. The universal quality here is the desire to engage in this process rather than painting some ideal version of a particular piece of music.

1. *Jazz Painting*, painting done to music, acrylic and charcoal on paper, by Angela McGuire.
2–3. Painting to music, mixed media.
4. *Landscape*, painting to music, oil on canvas, by Christopher Willingham.

5. Slow painting to classical music, watercolor on paper.

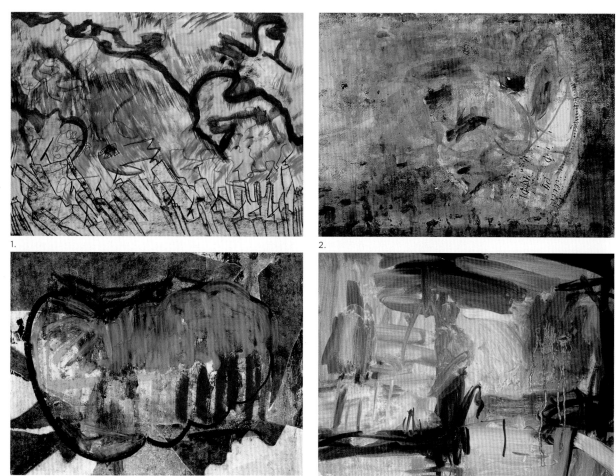

1.

2.

3.

4.

5.

Other Exercises to Try

→ Play the same song or composition a second and third time and paint a new response to it each time.

→ Rather than listening to recorded music, listen to the quiet sounds that happen all around you that you don't hear unless you're listening for them. If you want to hear and respond to these "sounds of silence," you really should do this with your eyes closed or blindfolded.

→ Work subtractively—coat the surface of your paper with soft charcoal and, as the music changes, erase or wipe away the surface to create gestures.

→ A fun exercise to do with a partner is to each take turns making noises— clapping, singing, whistling, shouting, etc.—for your partner to paint.

→ An ideal way to paint from music is to have a musician play an instrument for you, particularly if he or she plays free-form jazz, where you can both improvise. My artist friend Kristen Mills makes arrangements with jazz and blues bands to paint to their music live as they are performing in clubs. As many people come to see her work as come to hear the music—a nice gig if you can get it!

Don't forget to select examples from these exercises to put into your Like, Dislike, and TBC portfolios, and work on ideas in your sketchbook for future reference!

Artists on Intuition "I make my paintings listening to live music that is being performed in front of an audience in bars or jazz music clubs. In other words, I set up my canvas and materials right there in the club, and I paint directly when the group is playing. These paintings are my interpretations of the sounds, rhythms, and movements that I hear and see at these events. My paintings are purely spontaneous and impromptu expressions of the music I hear. I paint what I feel subjectively, rather than trying to 'picture' what I hear. This type of painting has helped me break down my own barriers between painting what I see and painting what I hear in music, and that process is a new visual language in oil paint." Kristen Mills

Stick With It!
OVERCOMING "ARTIST'S BLOCK"

Opposite page: *Music for Jess*, a painting made to live music at a jazz club, acrylic on canvas, by Kristin Mills.

Artist's block is a normal part of the creative process that literally all artists experience at one time or another—a kind of paralysis that comes over you when you feel uninspired or unmotivated to make art. For newcomers, this experience may come as a shock, and they may feel completely unprepared. With more practiced artists, this kind of block can be both frustrating and debilitating. The main strategy for overcoming artist's block is to keep making art, and not dwell on those things that make you want to give up. Artist's block can take on many different forms that can range from being blocked because you haven't made art in a long time—and you don't know how to get started again—to feeling that your work has become too predictable or lacks in new ideas. It is essential to prepare a defense against artist's block before it becomes a problem. The following strategies can help you prevent and overcome symptoms of artist's block, and help you to get back on track with your work.

Use your sketchbook. Keeping a sketchbook is like having an artist's rainy-day savings account that can help when you need it most. Your sketchbook is a great resource for breaking yourself out of a block because it contains valuable notes for possible themes or projects.

Keep up your portfolio. As discussed in Chapter One, it's important to keep the Like, Dislike, and TBC portfolios well stocked. They can present you with options to work on that can see you through a blocked period. If you haven't been saving examples of your work in these portfolios, I strongly recommend that you begin that process as soon as possible. You may need those materials someday!

Do the projects in this book. One of the main objectives of *Art from Intuition* is to keep you from getting stuck or blocked; any one of the projects in this book can help you overcome artist's block and get you back to creating freely. Specific exercises you can try when you feel stuck and in need of a quick jumpstart are: Automatic Drawing (p. 46), 30 Sketches in 30 Minutes (p. 51), and Out of the Shadows (p. 89).

If you are blocked because your work is becoming dull or uninspired, it may be because you are reluctant to leave your artist's comfort zone or that you are being lazy about moving into some new territory. Some exercises that combat this kind of block are Painting to Music (p. 37), Simple Collage (p. 73), Mapping Your Mind (p. 94), and Drawing with Smoke (p. 106).

Challenge yourself to explore new territory. First, try any of the exercises in this book that seem completely foreign to you— those projects that sound weird, silly, or even ridiculous. I'm posing the challenge that nothing is weird, silly, or ridiculous when you are making art, and that you need to go to those places in order to find gold in the sand!

Next, you can try to make "bad art." Making "bad art" means that you must try to make the most obnoxious art you can think of—pictures with terrible colors and bad painting techniques or art that is based on themes you could never consider using. Trying to make so-called bad art isn't as easy as you think, and to pull this off you need to make a sincere effort to use what you consider to be horrible colors or subjects you don't consider worthy of painting, or use your skills and art-making techniques with total abandon. Making bad art may sound crazy, but it's certainly a fun idea to explore. Keep in mind that Andy Warhol's Campbell's Soup cans and Brillo boxes were originally a personal joke tossed out at the elitist art world that later became some of the best-loved icons of the Pop Art movement.

Don't Think Now: Stimulating Your Intuition

CHAPTER THREE

Indeed, **don't** *think now!* Thinking out loud in your head about things like "When will this drawing be finished?" or "Is this picture going to be any good?" is a surefire way to short-circuit your intuitive creativity. Attempting to draw or paint with such thoughts in your mind is like trying to drive a car from the passenger seat—it simply doesn't work! The panacea for this problem is to allow your instincts and intuition to take full control of the creative process. In order to learn this essential skill, you have to be completely engaged in the creative process itself (without thinking about it) for the process to work.

By sticking to the principle of "Don't think—*do*!" the projects in this chapter show you how to use your spontaneous impulse to create. These projects are specifically designed to help you overcome your fear of the dreaded blank page. Keeping in mind the techniques of working with youthful abandon and improvisation explored in the previous chapter, you can break through those self-imposed barriers that hold you back as an artist and learn to better enjoy the experience of painting or drawing.

AUTOMATIC DRAWING:
JUST START DRAWING AND KEEP GOING

Like its literary counterpart, "automatic writing," automatic drawing means to draw using free association, anything that comes into your mind without trying to plan, compose, or control what happens. Automatic drawing emphasizes the *"Don't think!"* imperative. The idea is to develop a composition by starting anywhere on your paper with any materials, adding marks and dashes of color, and letting the drawing take shape on its own. To draw "automatically" means to let the process take over and guide you as you work. As you go, you continue to add to and subtract from this composition, depending on what your instincts and intuition direct you to do. The point of an automatic drawing is to allow the picture to tell you where *it* wants to go and not to force it or direct it toward some preconceived image. To accomplish this goal, you must place your complete trust in the automatic drawing process and see where it takes you.

Materials

- ➜ 18 × 24 newsprint or other drawing paper
- ➜ Drawing pencils and pens
- ➜ Charcoal and pastels
- ➜ Erasers
- ➜ Paints and inks
- ➜ Various brushes and painting materials
- ➜ Additional materials that appeal to you

Exercise 1. Keep It Quick and Simple

When setting up for the first time, choose the drawing or painting materials you are most comfortable working with and get them ready. I suggest inexpensive supplies, so that you can feel free to experiment without worrying about the cost of your materials.

If you are going to be using paint, you may want to use a heavier paper like an 80-lb. bond paper, which will hold the paint better than newsprint. I also recommend that you work on larger-sized paper, at least 18 × 24, so that you have room to move around and experiment in a larger space.

The idea is simply to make a mark or brushstroke on your paper and to follow up with the next spontaneous gesture, and then to keep going from there. Don't think at all about whether this will be a "good" drawing or not, since that idea is always going to slow you down and get you off track.

When images or patterns begin to develop, you may respond to what emerges and take a cue from what you see. Keep in mind that you can use erasers or opaque paints to open up your composition or change the shapes,

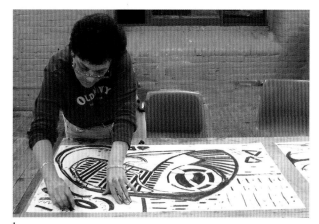

1.

2.

3.

1. Automatic drawing in progress, charcoal on paper.

2. Automatic drawing using a geometric motif, charcoal on paper.

3. Five-minute automatic drawing using spontaneous repeated shapes, charcoal on paper.

patterns, or textures as you see fit—both an additive and a subtractive process. Some of your marks may only be doodles and random scribbles, while others may take on forms that suggest an object, a figure, or an abstract landscape.

In this first set of drawings, keep things quick and simple by limiting yourself to no more than five minutes for each piece. As soon as you have some initial shapes, marks, and textures that look interesting, stop working on that drawing and go on to the next one. Afterward, remember to sort through these images for potential candidates for your Like, Don't Like, and TBC portfolios.

Exercise 2. Take It to the Next Level

Once you have made at least ten initial automatic drawings, choose two or three that you feel have potential for further development. In other words, you may choose a piece that has open areas to work into, one that seems to need more color, texture, or shading, or one that you just have a hunch about. This is a good opportunity to allow your intuition to guide in both choosing drawings and in what you decide to do with them.

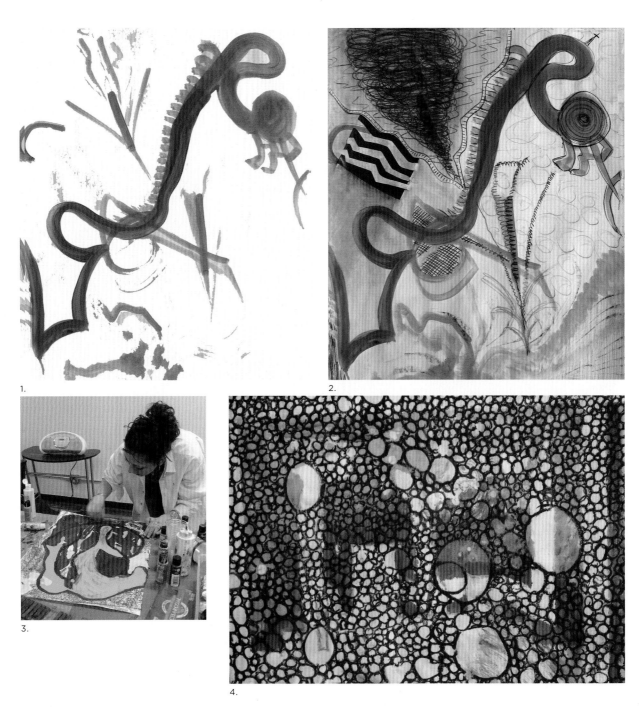

1.

2.

3.

4.

Exercise 3. Know When to Stop

Another issue that comes up in automatic drawing (as well as in all artistic pursuits) is the dreaded question of knowing when to stop! This elusive boundary has no agreed-to rules or guidelines, and we are forced to make such decisions on our own: The bottom line is that deciding when to stop working on a painting or drawing and say that it is finished is essentially a subjective matter. Of course, it can all get very messy as soon as other artists, friends, teachers, and self-appointed art critics get involved. But this is a good time to start making these very decisions about "finished," "not finished," "good," or "not so good" in your own work. In order to know when to stop, you may have to cross the line of going too far—this is overdone, overcooked, I went overboard, etc. So just take some of your automatic drawings and push them as far as you can until it's clear that adding one more thing may be too much!

5.

6.

7.

1. First five-minute stage of an automatic drawing.
2. Completed drawing that was developed from the five-minute sketch.
3. Student working on an automatic drawing that emphasizes color, acrylic on paper.
4. Built-up layers of automatic drawings, charcoal and acrylic on paper.

5. Balanced composition of color and texture that was stopped before being overworked.
6. Charcoal drawing that achieves a good balance of textural detail and open, negative space.
7. Balanced composition using contrasting colors and shapes, mixed-media collage on paper, by Susan H. Benford.

Other Exercises to Try

→ Create automatic drawings that begin from a theme in mind, such as beams of light, the textures of waves, or the sound of a jet engine.

→ Use your opposite hand to make the drawing, or stick a piece of charcoal between your toes and draw with your feet. This will cause you to pay attention to drawing as a *physical* process and be less concerned about controlling the marks and the images you might make.

→ Try an unusual form of mark-making, like tying your charcoal to a stick or drawing with a long straw dipped in ink.

→ Automatic drawing is perfectly suited to doodling (a time-honored form of automatic drawing) in your sketchbook. You can make this a regular part of your sketchbook routine to help develop new ideas seemingly out of nowhere.

Don't forget to select examples from these exercises to put into your Like, Dislike, and TBC portfolios, and work on ideas in your sketchbook for future reference!

30 SKETCHES IN 30 MINUTES:
DRAWING WITH NO TIME TO THINK

The idea of drawing 30 Sketches in 30 Minutes is to make quick and simple, line-only sketches that capture the essential visual aspects of an object or other observed subject. This process is similar to making sketchbook notations, only with the addition of a strict time constraint.

Doing one drawing per minute is intended to get you moving so fast that you don't have time to think and analyze what each sketch looks like—remember, "Don't think—*do!*" This quick-drawing process can be a good warm-up exercise with no particular goal or outcome in mind. Making a series of one-minute sketches can help you observe a subject from vantage points and perspectives that you might not otherwise see, as well as gather lots of information without stopping to analyze it.

Opposite page: Balanced composition emphasizing line, shape, and color.

Materials

➜ Newsprint or 8½ × 11 copy paper
➜ Soft pencil, felt-tipped markers, or stick charcoal
➜ Egg timer that can be set for one minute (optional)
➜ Additional materials of your choice

Exercise 1. Choose an Intriguing Object to Draw

You will need thirty separate sheets of cheap copy paper, or you can divide larger pages of newsprint into smaller rectangles. Don't bother to use a ruler to measure out these rectangles since they are just a casual boundary for separating one drawing from another. The important thing is that each drawing area be at least 8 × 10 so you have enough room to move around without feeling cramped for space. Choose a soft pencil, a piece of charcoal, or a felt-tipped marker to make these sketches. Remember that you are just making quick line drawings and that you needn't erase or correct as you go along—there's no time to do so anyway.

As for keeping time, I suggest that you use your own internal clock rather than setting up a timer to signal you when to stop. If you're not sure how long a minute lasts, set an egg timer for the first few sketches to get used to how a minute feels, and then simply wing it. The point is that you want to keep moving along at a steady pace so you can't get hung up on any one drawing. The thirty-minute time limit is flexible (though a minute should not last five minutes in reality), and it may take you additional time to go from one drawing to the next, particularly if you are working outside, as is suggested in subsequent exercises.

1. One-minute sketches of various angles and details from the still-life object pictured to the right.

2. Student drawing 30 Sketches from the still-life object.

Once you've set up your materials, you need to choose an interesting object to draw. By interesting, I mean an object that has enough facets and shapes to hold your attention for thirty distinct observations. It's worth taking the time beforehand to find something you'd like to draw rather than just beginning with anything that happens to be sitting nearby.

As you progress in your series, try such variations as zooming in on the object and blowing up its details, or looking at this object from different vantage points. You can also manipulate the lighting on the object to create different shadows or reflections that will give you additional shapes to work from. Your interpretation of this object may be imprecise or distorted, but this is to be expected, given the time constraints involved. Remember that you aren't trying to make ART with a capital A; you're simply making sketches to gather ideas. The time spent doing them will add to your powers of intuition and help train your eye for observing nature—nothing is wasted!

I recommend that you repeat this exercise right after completing the first set, while this process is still fresh in your mind. Switch to a new object—one noticeably different in size, shape, and texture—for the second set of thirty drawings, to avoid getting bored with the process.

1.

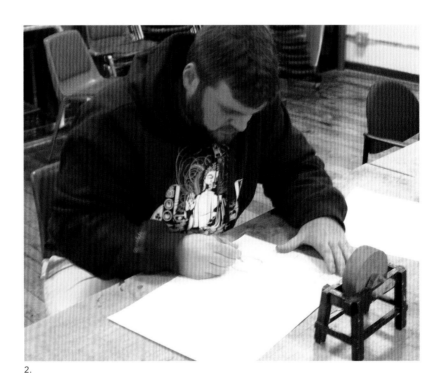

2.

Exercise 2. Develop Your Initial Sketches

Take a look through the sketches you completed in Exercise 1 to find particular drawings that spark your interest. Choose one of these sketches that you feel has potential for further development, and continue to work on it to see where it goes.

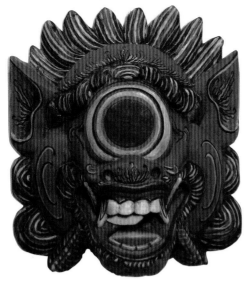

3.

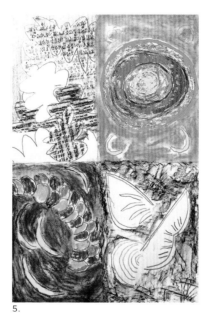

3. Tribal mask used as a subject for 30 Sketches in 30 Minutes.

4. Sketch of tribal mask developed into a four-part composition.

5. Drawing developed by adding charcoal pencil and watercolor directly onto sketch.

6. Detail of sketch of the tribal mask.

7. Design created from the previous sketch.

4.

5.

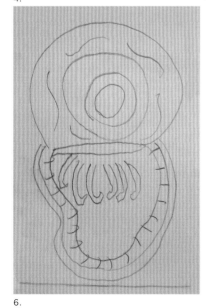

6.

7.

Exercise 3. Working Outside

30 Sketches in 30 Minutes can also be done working outdoors; however, keep in mind that the open space can make it more challenging to focus on a subject. Try to find an object or a group of natural forms that you can isolate from their surroundings, and then make your drawings from various angles. The example below shows how this student added deep blacks and shading to a page filled with thirty drawings to achieve an overall dramatic effect.

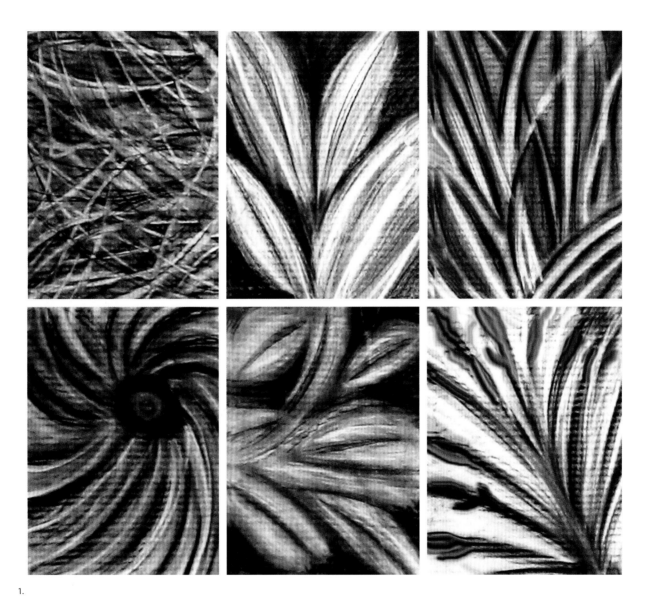

1.

1. Sketches of foliage details, made while working outside.

Exercise 4: Location, Location, Location

If you are looking for dramatic subjects to draw, you can work onsite at a natural history museum, in a sculpture park, or in an outdoor setting like a botanical garden. If you decide to study a complex object (like a skeleton), you should narrow your focus to details of the object that are composed of just a few shapes. The advantage of using a complex subject is that you can move quickly from one interesting area to another, isolating those that catch your eye. Again, these sketches can be very simple drawings of just a few marks that might suggest only the essential forms you are observing.

2–4. Students drawing onsite.

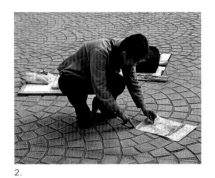

2.

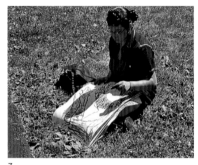

3.

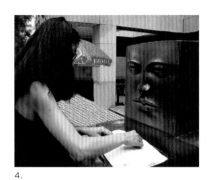

4.

Other Exercises to Try

→ The 30 Sketches exercise can also be used when you are working solely from your imagination or memory. In other words, you might try to draw an image that is in your mind's eye or simply draw spontaneously, letting the drawing go anywhere it wants to, as we did in the Automatic Drawing project. You may want to decide on a theme before you start off on this exercise, such as geometric or organic shapes, or dreams, or perhaps apply other exercises like Painting to Music or Action Painting.

→ Instead of drawing out ideas in your sketchbook, simply jot down as many as you can think of in thirty minutes. For example, (1) Paint nightscapes; (2) Make macro studies of leaves; (3) Draw an icecube melting; (4) Draw on eggshells; (5) Paint stripes of pure color; or (6) Paint outside in a snowstorm. The list is endless. You should set a goal of at least one to two ideas per minute, to force yourself to grind out as much potential food for thought as you can. Even though practically it may only be possible to do a few of these ideas, remember: The main point of this exercise is to push yourself to extend the range of creative possibilities for your art.

Don't forget to select examples from these exercises to put into your Like, Dislike, and TBC portfolios, and work on ideas in your sketchbook for future reference!

SIMPLE COMPOSITIONS:
THE MANTRA IS—LESS IS MORE

You've heard it said that "Less is more," and this familiar saying can be especially true in visual art. In fact, one of the most difficult things to accomplish in art is to create a clean, uncluttered composition that conveys a strong and compelling image. By "simple" I don't necessarily mean minimal compositions that have only a few visual elements. Rather, I'm suggesting that you limit your use of different mediums and keep combinations of color, space, line, texture, and value to a selective grouping in order to achieve an elegant sense of overall order. The real emphasis here is on composition itself. Before you decide to compose a complex scene or still-life arrangement, it is important to study the underpinnings of placement and balance that hold that composition together. The following exercises are designed to help you to take advantage of the intuitive process in order to create strong and simple compositions.

Materials

→ Bond or Bristol paper, at least 11 × 14
→ Charcoal, colored pencils, or pastels
→ Assorted brushes
→ India or Sumi ink
→ Acrylic or water-based paints
→ Colored craft paper and collage materials
→ Glue sticks
→ Additional materials that appeal to you

Exercise 1. Simple Compositions Emphasizing Simple Shapes in Open Space
The objective for this exercise is to create dynamic compositions that are composed of only a few shapes in an open background space. There are many ways to approach this idea—from sketching out thumbnail drawings that explore the contour, size, and position of the main shapes, to cutting out individual shapes from colored papers and pushing them around until you decide where they belong in your composition. A novel, chance approach to this exercise is to cut up several different colors of craft paper into various large and small organic and geometric shapes. Once you've made this stock material, put the pieces into a hat and mix them up. Closing your eyes, choose just three shapes at random from the pile in the hat. The three shapes you pick out are the ones that you will use to make your simple composition.

Once you have the shapes you want to use, you can begin to work through your own trial and error experiments that help you gauge where those shapes belong in your composition. This is the point at which your intuitive eye comes

1.

2.

into play because there is no correct answer for the question of where these shapes and colors belong in your composition—you'll just have to push them around until you see it. I'm not offering step-by-step illustrations for this process because I don't want to prejudice what your compositions should look like before you've tried this process yourself. The challenge in this exercise is to set aside conscious ideas about what might go where and what looks good and trust your intuition to figure that out.

Exercise 2. Simple Compositions Emphasizing Color and Texture

This exercise isolates color and texture as the prime elements for building your composition. We are using these two elements as contrasting ingredients in your simple composition. As in Exercise 1, choose a limited group of shapes and colors to work with and sketch out different possibilities for arrangements of these shapes and colors in your sketchbook or on separate pieces of paper. Once you've arrived at some interesting compositional ideas, start to experiment with adding textural patterns that contrast with your colored shapes to create dynamic juxtapositions and shifts of visual energy.

1. *End point*, simple composition, by Kanji Wakae.
2. Dramatic organic shape in an open space, simple composition.

3-4. Simple compositions with contrasting colors and textures.

3.

4.

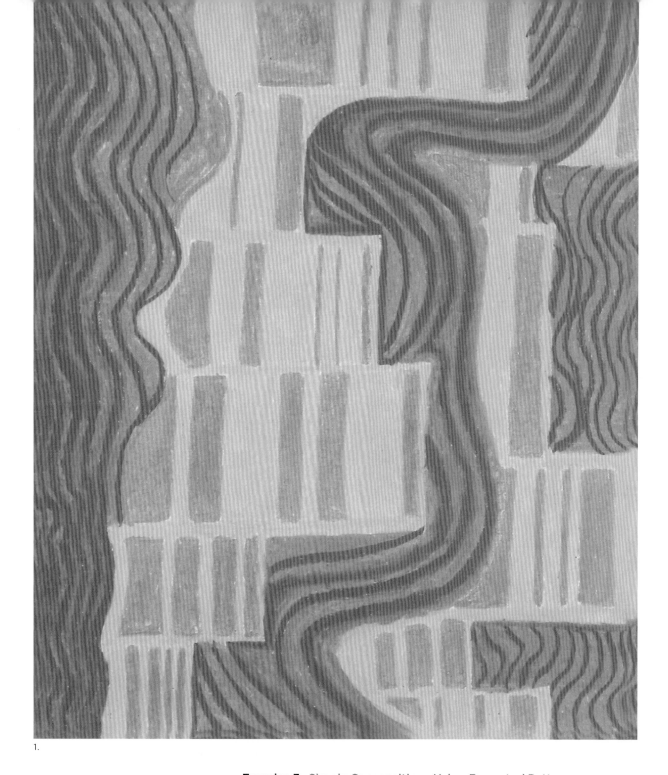

1.

Exercise 3. Simple Compositions Using Repeated Patterns

You can create a simple composition using a repeated shape, texture, or color as the central building block of your composition. Start this process with a single element, (shape, texture, or color) and then repeat that element throughout the work.

1. Simple composition with contrasting colors and textures.

2.

3.

4.

5.

6.

2. *Still Life*, simple composition, acrylic on canvas, by Rob Moore.

3. Simple composition using a repeated shape motif.

4. Simple composition using a varied color motif.

5–6. Simple composition using a varied shape and color motif.

Other Exercises to Try

→ Choose a simple mark or shape that exists in a previous work, and create a complete composition using only that mark or shape. This composition can either isolate that form or use it as part of a repetitive pattern.

→ Work back into some of your simple compositions with other materials, or use a process from another project in this book. The pieces you make for this project can be the beginnings of more elaborate developments in other artworks.

→ To create more variation, prepare some of your paper with washes and stains before you start your composition. These should be quick, loose background tones and colors that give you a little more to respond to than just a blank page.

Don't forget to select examples from these exercises to put into your Like, Dislike, and TBC portfolios, and work on ideas in your sketchbook for future reference!

SIMPLE PRINTS:
EASY OFF-PRESS PRINTMAKING

As children, most of us discovered the instant gratification that comes from making potato prints or pressing inked leaves on a piece of paper. There was an excitement to be had when you peeled away the paper from the printing plate because you were never exactly sure what you were going to see. You also discovered that even these primitive forms of printmaking produced a distinctive kind of image that you couldn't make any other way. The art of printmaking is widely practiced by artists at all levels because of its unique visual properties as well as the element of surprise that comes with it.

The exercises here use direct printmaking methods that are achieved by hand without needing a press or other expensive equipment. All the print methods take the form of "monotypes" (one-of-a-kind prints, as opposed to print editions), where you are reproducing several copies of the same print. Monotypes can remain as a one-shot print or be embellished with additional colors and drawing techniques to comprise the finished work. I use these simple print processes in my own work as another way of achieving dramatic effects of light and shadow and prominent passages of color that add to my overall art-making tool kit.

The following exercises take advantage of easily accessible materials like wax paper, corrugated cardboard, pieces of wood, and everyday objects to make prints without needing to buy expensive supplies. As with other techniques presented in this book, Simple Prints puts the emphasis on using your intuition and spontaneity to spark your artistic creativity.

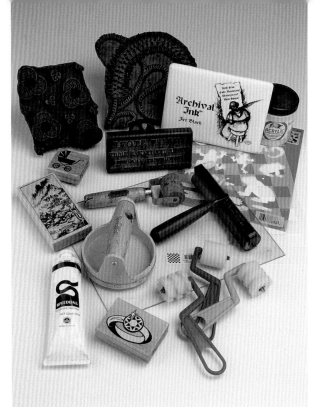

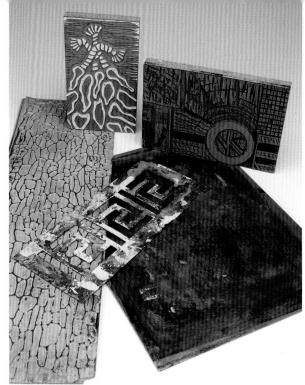

1. 2.

DISCLAIMER—Before I describe the exercises in this project, it's important for me to emphasize that I'm not teaching a printmaking class in these pages—that's a topic for another book. I'm giving you only the essential information you need to get started on a process; your curiosity and intuition can take it from there. An excellent resource to learn more about these and other printmaking processes is the book *Monotype: Mediums and Methods for Painterly Printmaking* by Julia Ayres, Watson-Guptill Publications, 2001.

1. Basic printmaking supplies.
2. Printing plates.

Materials

→ Drawing or bond paper (white, 80-lb. or more)
→ Optional printmaking papers (140-lb. or more)
→ Corrugated cardboard
→ Linoleum or wood blocks
→ Wood/linoleum-cutting tools
→ India ink
→ Plexiglas plate
→ Burin or spoon rubbing tool
→ Water-based block-printing inks
→ Acrylic or tempera paints
→ Brushes, sponges, rags
→ Brayer (a hand-inking roller), paint rollers, printing burin
→ X-Acto blades or mat knives
→ Other materials of your choice

Exercise 1. Make Inkblot Prints

Probably the easiest and most accessible print process is that of inkblot transfers or so-called Rorschach prints. These types of prints are made by dripping, splattering, or brushing ink randomly onto one half of your paper and then folding it in half while the medium is still wet to make the print—nothing could be easier. When you put your medium (ink or paint) on the paper, experiment with making shapes of different sizes, colors, and with varying amounts of medium. Also try using different tools and techniques to apply your medium—rags, sponges, an ink roller, a painting knife, scraps of cardboard, etc. You can layer different blots by folding and refolding the paper several times to build up the depth of the image. Starting with these suggestions, you can invent your own techniques, which can be developed into varied and beautiful compositions.

1.

3.

4.

2.

Opposite page: Untitled inkblot print, mixed media on canvas, by John Calhoun.

1. *Pink Hippos*, folded and altered print, acrylic on paper, by Aryn Banas.
2. Folded inkblot print.
3. Folded inkblot print, by Chong Bang.
4. Folded inkblot print in progress, acrylic on paper, by Velma J. Magill.

Exercise 2. Experiment with Printing Plates

This exercise stays in the "simple to do" arena by taking the method of direct-transfer printmaking used in the exercise above one step further. The difference here is that you will apply ink or paint to a separate surface and transfer it to another surface to make your print. The first method is to use a heavy piece of paper or cardboard as your printing plate and to paint it with thick, gooey brushstrokes, and then to press it onto your paper or canvas. You can get different effects with this technique either by changing the type and viscosity of the paint or ink that you use or by modifying the time you take before making the transfer.

For a variation on this technique, use slick surfaces such as glass, Plexiglas, aluminum foil, wax paper, or sheet metal as your plate. Surfaces like these release the paint medium more completely than do more absorbent materials. Experiment using various materials as your plate to discover your own preferences.

Any of these monoprints can be developed further by repeating this transfer process; simply clean the plate and apply more paint to change the design and print it again over the first print. The more you experiment with this easy, direct print process, the more dramatic effects you can achieve.

1. Stencil and wax paper simple print, acrylic on paper, by Ryan Rege.
2. *Spiral*, Plexiglas direct transfer print, ink on paper print, by Ryan Rege.

Opposite page: *Woodland 57*, stamps and direct transfer print, ink and acrylic on paper, by Angela McGuire.

1.

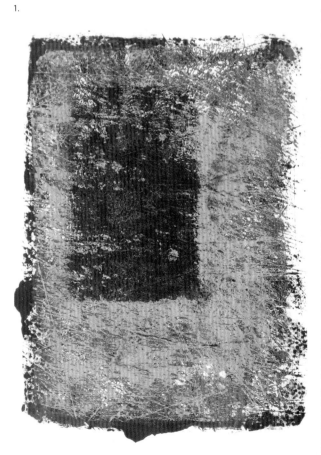

2.

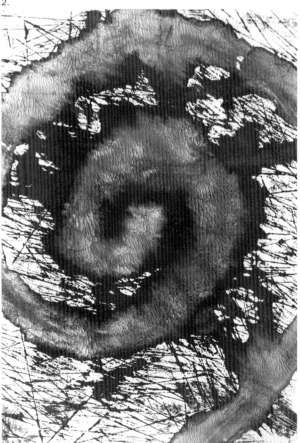

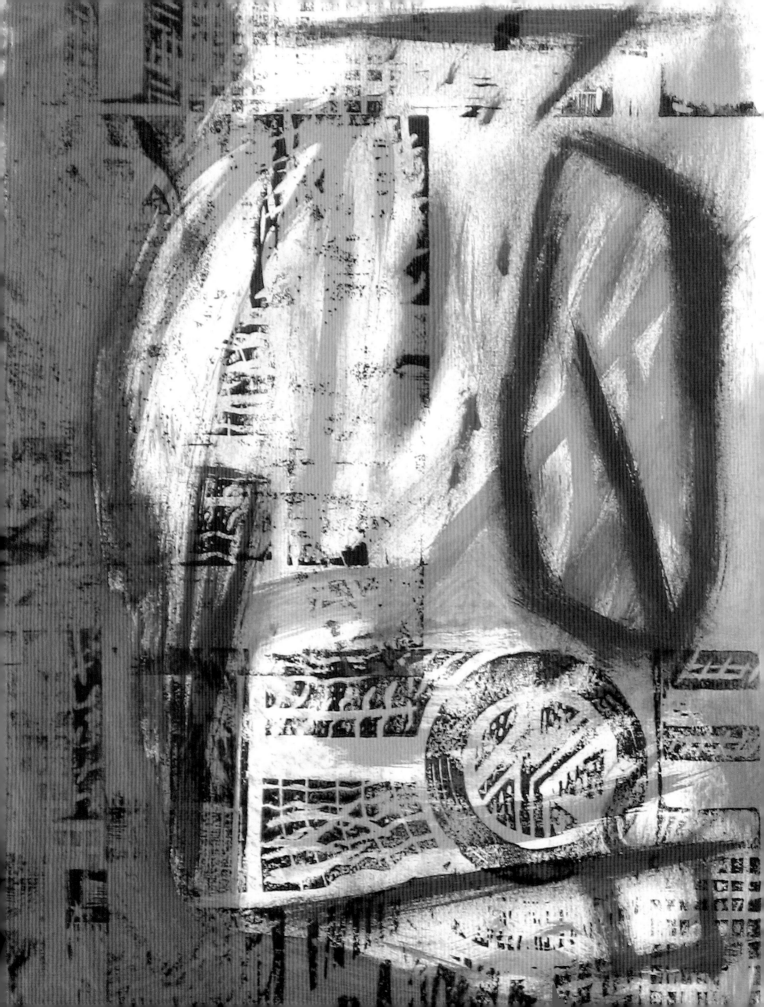

Exercise 3. Make and Use Collagraphs

Another kind of direct relief-printing technique is called a collagraph. Simple collagraphs are made by first attaching low-relief textured material like paper, string, fabric, or sand to a cardboard backing using any kind of white glue. Next, this plate should be coated with a water-based sealer like gloss gel medium or gloss acrylic varnish (two coats recommended). When this is completely dry, ink or paint the surface using a brush, paint roller, or a printmaking brayer. Each of these tools creates a different effect on the print. Once you've inked the plate, lay your paper over it and burnish the back of the print with your hands, a wooden spoon, or other tool to transfer the image. Here, too, you can achieve a wide variety of outcomes depending on how you tweak the process. The amount of color you use, how you apply the medium, how hard you burnish the print, etc., can change the results dramatically.

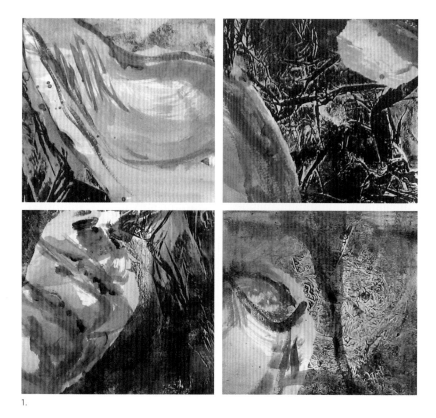

1.

1. *Form Study*, foil transfer, ink, watercolor, and charcoal on paper, by Deborah Ford.
2. Collagraph cardboard for printing plate.
3. Textured materials for collagraph plate.
4. Collagraph print using cardboard relief-printing plate.
5. Stencil print with acrylic and charcoal on paper.
6. Collagraph cardboard relief-printing plate.
7. Hand-colored collagraph relief print using cardboard printing plate.

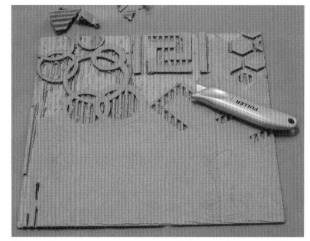

2.

3.

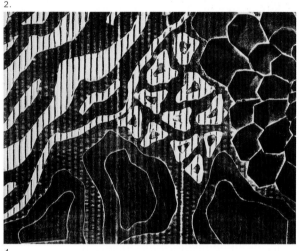

4.

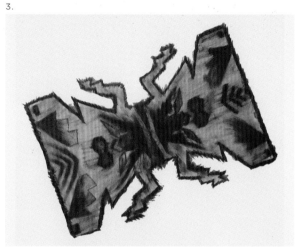

5.

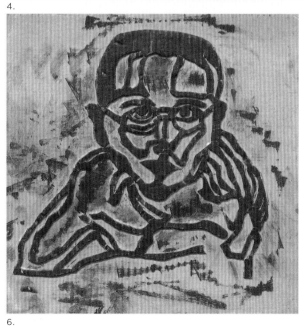

6.

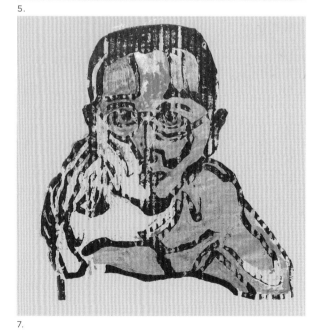

7.

Exercise 4. More Relief-Printing Methods

Another relief-print system is that which uses linoleum or woodblock printing methods. I'm going to once again invoke my disclaimer that I will not go into excessive detail about how to make these kinds of prints, as the process is pretty self-explanatory. The materials you need are commercial linoleum blocks (available in various sizes) or flat pieces of scrap wood that can be any size or shape, along with gouges to dig into the surface of the printing plate. Linoleum blocks are available at any art store.

The basic method is to dig into your linoleum or woodblock using various sizes of gouges to create your print image. Be careful to keep your hands out of harm's way. Once completed, you simply ink your printing plate and burnish it as you did your collagraphs in Exercise 3, and then experiment with variations that lead to more possibilities.

A more labor-intensive method of relief printing is to carve a piece of corrugated cardboard or other material with an X-Acto knife or other sharp tool, stripping away the negative space to reveal the shapes you want to print. Although this printmaking process is more time consuming than some of the others, the radically different results that you will get using this process may make you prefer it to the easier methods.

1. Cutting design into linoleum block.
2. Preparing to ink the block.
3. Rubbing linoleum block print with burin.
4. Finished linoleum block print.

Opposite page: Hand-rubbed woodcut, ink on paper, by Gregory Amenoff.

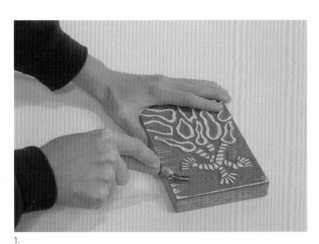

1.

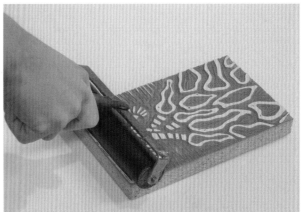

2.

3.

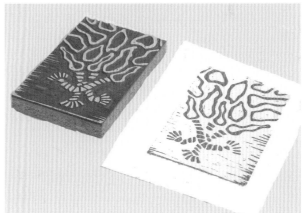

4.

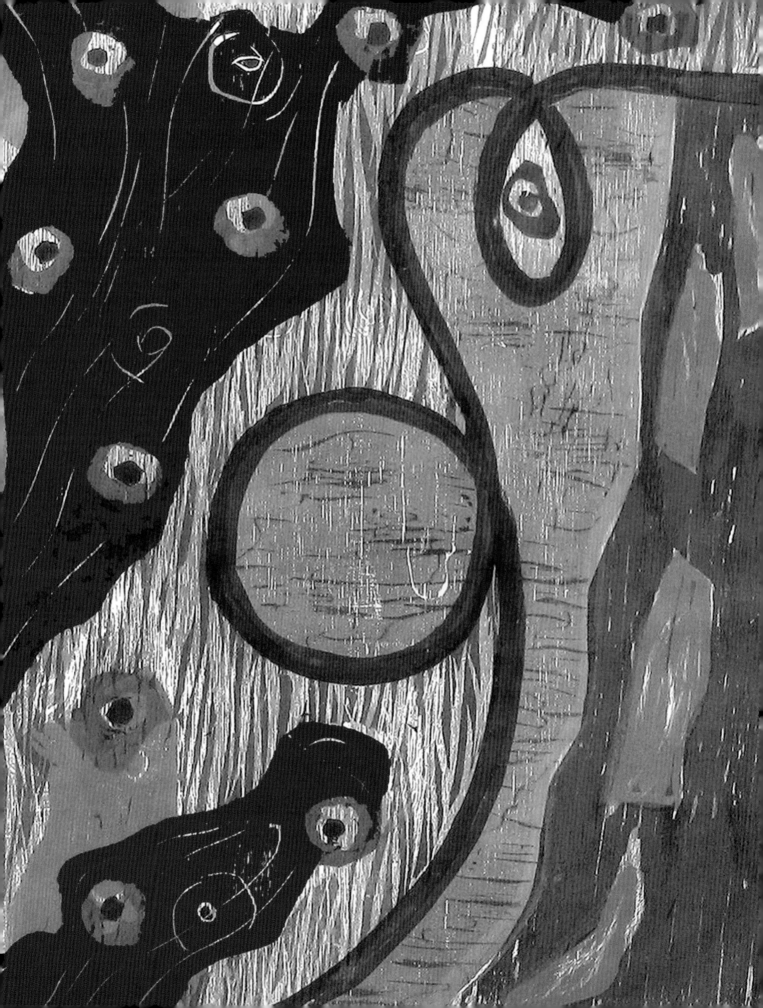

Exercise 5. Make Prints from Cutouts

Remember making paper snowflakes as a child? Well, now you can use that very same process to make cutouts from which you can then make prints. The cutouts can be made from paper or wax paper and they can be used in a couple of ways. They can block out the ink or paint, or the blank shape can be used as a stencil to print the form directly. There are many variations that can be achieved with combinations of these techniques used in repeated formations.

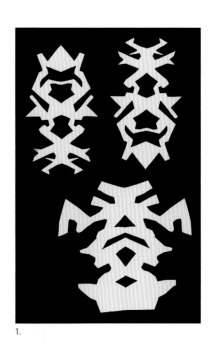

1.

1. Simple stencil print, reversed image.
2. Simple stencil print, ink on paper.

3. *Self-portrait*, ink, collage, and solvent transfer print, by Jane Davies.
4. Rubber-stamp print, by Corey Nimmer.
5–8. Direct print, rubber stamping, and fingerprints on old records.

2.

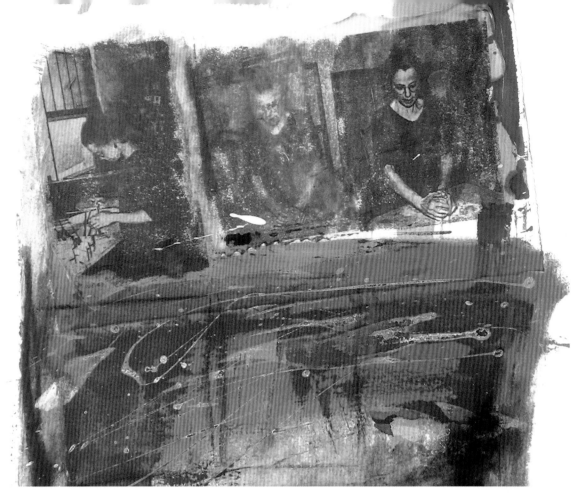

3.

5.

7.

6.

8.

4.

Other Exercises to Try

→ Use other tools, like commercial rubber stamps that come in both word and image styles, to make prints. You can also make your own stamps out of erasers or rubber-stamp bases that you can buy in an art or craft store. Old wooden type and wooden fabric hand printers make excellent direct prints. And, of course, you can create prints using only your fingers by composing repetitious sequences of fingerprints.

→ Rubbings are another kind of simple print process that offers many creative possibilities. You may be familiar with gravestone rubbings, which capture the text and images from the surface of a monument by burnishing soft charcoal over a thin piece of paper to reveal the surface texture below. This same rubbing transfer process can be used with any textured surface to create a rich variety of direct prints. For example, you can make rubbings from various surfaces (from sandpaper, a cheese grater, the sidewalk, etc.) directly onto your drawing to create another kind of simple print.

Don't forget to select examples from these exercises to put into your Like, Dislike, and TBC portfolios, and work on ideas in your sketchbook for future reference!

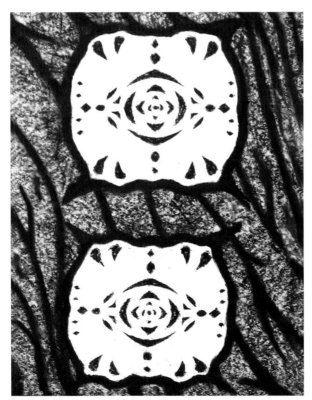

1.

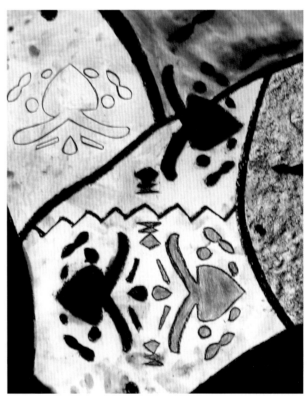

2.

1. Drawing and stencil print, charcoal on paper.
2. Simple prints: stencil print, ink, and charcoal on paper.

SIMPLE COLLAGE:
THE ART OF PUTTING THINGS TOGETHER

Collage is so well known and popular that it needs practically no introduction. As with Simple Prints, I am not going to elaborate on any exotic collage techniques or write at length about the philosophy of the art of collage. This technique is quite accessible and easy to work with, and you don't have to know many sophisticated techniques in order to use collage in your work.

The exercises in this section use both customary and experimental strategies to expand the possibilities for incorporating collage. This art of putting things together can be used by itself or in combination with drawing, painting, and printmaking techniques, which is called "mixed media." So gather a stock of collage materials that you find interesting, and get your glues and paints ready to go.

Materials

→ Heavy drawing paper, tagboard, cardboard, or canvas used as a backboard to glue down your collage
→ Colored craft paper
→ Books, magazines, fabrics, wrappers and packaging, stickers, rubber stamps, small found objects, and anything that can be glued down
→ Glue sticks and acrylic, mat medium for paper
→ White or wood glue for heavier objects and fabrics
→ 5 × 7 blank note cards
→ Additional materials of your choosing

Exercise 1. Develop Collages from Work in Your TBC Portfolio
This first collage exercise involves choosing a drawing from your TBC portfolio that will serve as a base composition to be completed with collage. Look through your TBC portfolio for three or four unfinished drawings that seem to need the kinds of colors, textures, and tonal values available in the medium of collage. You want to have several options to work on so that you can compare what works with what doesn't in the end products. Once you've selected several pieces that have potential, choose one drawing to get started on. You may want to glue down the original drawing on a heavier backboard first, before adding the collage elements.

You can then begin to develop this drawing by adding collage and other media to the negative spaces between lines or by putting collage elements directly on top of the existing shapes in the original drawing. Use your intuition to decide where to place your collage elements to complete this composition. Here, too, there's no predictable step-by-step process, since each original base drawing will suggest how you proceed to add (or subtract) collage elements toward completing the work.

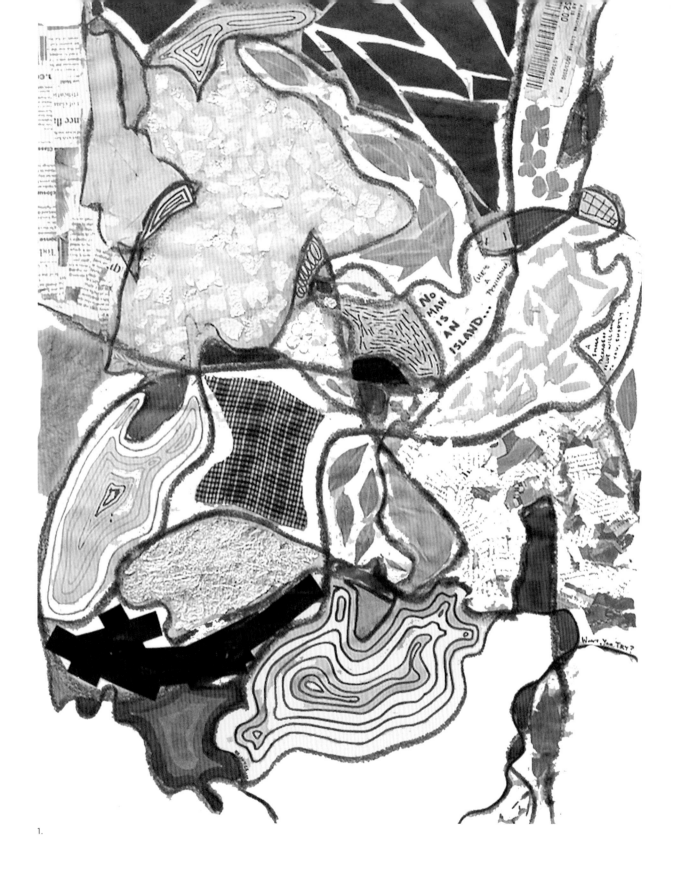

1.

1–4. Simple collages, mixed media on paper, student work developed from TBC portfolios.

ART FROM INTUITION

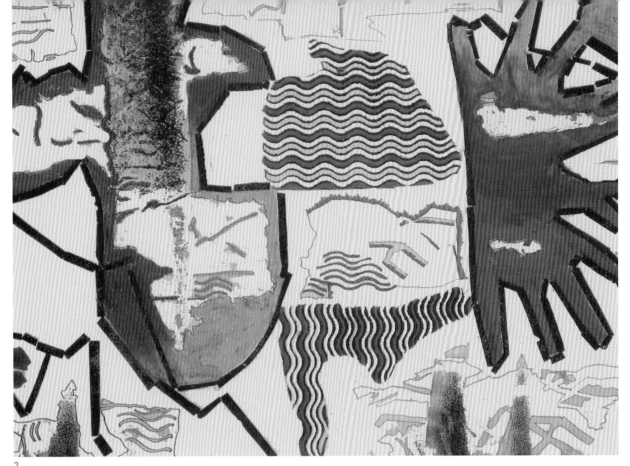

2.

3.

4.

Exercise 2. Go from Collage to Painting, and Back Again

This exercise explores how to use a collage composition as a sketch for a painting or drawing, and vice versa. The reason for working this way is that collage is a fast method for laying out ideas for compositions that would be time-consuming with conventional drawing or painting tools; it's also a great way to see what a painting might look like if it were made using another technique.

The first step is to create ten collages on 5 × 7 plain note cards using fast-drying glue sticks. These collages should be kept simple, consisting mainly of colors, shapes, and textures, without getting into more complicated arrangements of photos or text. Also, the collages made for this exercise are designed to utilize your spontaneity and intuition, so you don't want to get bogged down in picky details. Remember that these are casual creations, where the central objective is to vary each composition in an intriguing way. You also might want to refer back to the Simple Composition exercises found earlier in this chapter for some ideas.

Once you've completed all ten collages, look through them and choose one that you want to paint. Using any medium of your choice, study the collage composition, and lay out the basic shapes on your painting in pencil, remembering to keep approximately the same proportions as exist in the collage. Next you can paint the composition in any medium you choose, to see what happens.

Again, I'd like to stress that you always have the option of using the collage as a mere point of departure that can take you anywhere, and that you should feel free to interpret these collages in whatever way they strike you. So with this exercise you can be as free or as meticulous as suits your personality and still churn out new ideas for your art.

2.

1.

1. Cut-paper collage, study for a painting or drawing in another medium.

2. Simple collage, scrap-paper collage sketch for watercolor.

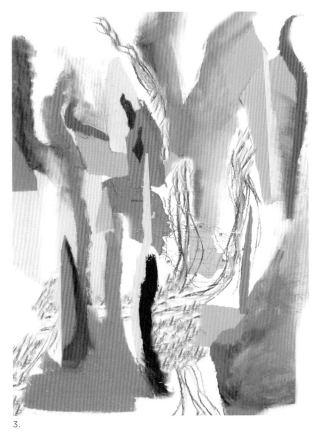

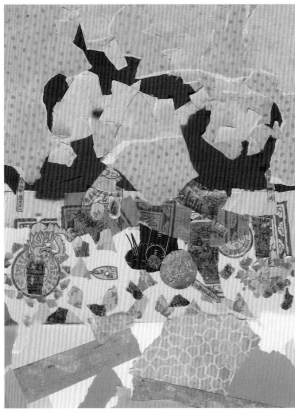

3.

4.

Exercise 3. "Anything Goes" Compositions

In order to take advantage of the "anything goes" mentality that collage encourages, start this exercise with a process called "random collage." Random collage was a surrealist technique in which the artist would tear up pieces of colored paper, photos, magazine clippings, and other odds and ends, and simply drop them onto the paper, allowing them to land wherever they would. The point of random collage is to leave the composition to chance rather than trying to control it. If you were to stick strictly to the surrealists' code of honor, you'd faithfully glue these pieces down exactly where they landed (true chance), and that would be your final composition. However, I have modified this technique and allow my students (and myself) the flexibility to adjust our compositions slightly or to get a second chance to drop the random collage. By replaying this chance game several times and making any adjustments that your intuition suggests, you can arrive at several startlingly original collages.

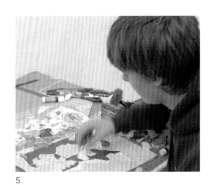

5.

There are also many variables you can adjust, such as the height and method of the drop and the degree to which you manipulate the result. Once you've made the drop, move some pieces around as needed and begin gluing down these fragments, letting them layer and overlap each other until you've secured all the pieces. Try not to think about what you'd like this collage to look like as you work on it; just let things happen automatically, and watch the composition take shape in front of you.

3-4. Simple random collages, mixed media on paper.
5. Student working a simple collage.

1.

2.

1. Billboard "natural collage" for sketchbook study.

2. Store-window collage for sketchbook studies.

Exercise 4. Get Inspired by "Natural" Collages

A rich resource for collage ideas is to go out hunting for "natural" collages in the environment and then to use them as an inspiration for your own collage work. The wind-torn billboard and the Halloween store window (both above) are good examples of natural collages that could inspire your own painting, drawing, or collage work. Draw or write notes about your natural collage finds in your sketchbook, or take photos with a digital camera to record these inspirations.

3.

Exercise 5. Collages with Themes

You can use the simple collage process to create works around a particular theme or central idea—these themes can be anything you choose, from the war in Iraq to a dream you had last night.

3. *Mr. Teapot*, mixed-media collage on paper, by Dean Nimmer.

1.

2.

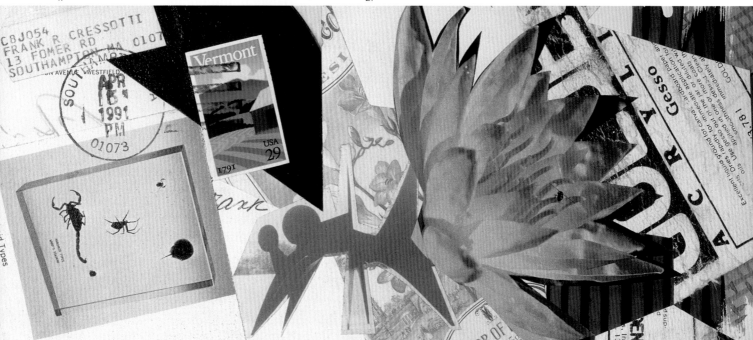

3.

1. Simple collage based on a war theme, acrylic and mixed media on board.
2. Simple collage based on a dream, mixed media on paper.
3. *Flycatcher*, mixed-media collage on canvas, by Frank Cressotti.

Other Exercises to Try:

→ Sort some of your materials beforehand according to various characteristics: shape, size, pattern, image, color, texture, etc. Then use the items in one or more of these categories to begin a series of collages.

→ Make a collage in which you leave some of the background open, letting the contours of your collage pieces and shapes become part of the overall design. You might prepare the surface first by painting a wash, staining, splattering, or coating it with another medium.

→ Some collages that you've stored in your TBC portfolio can always be torn up and reused in new works.

→ As you progress in this medium, your simple collage ideas can become the basis for more elaborate 2D and 3D assemblage works or large-scale installations.

Don't forget to select examples from these exercises to put into your Like, Dislike, and TBC portfolios, and work on ideas in your sketchbook for future reference!

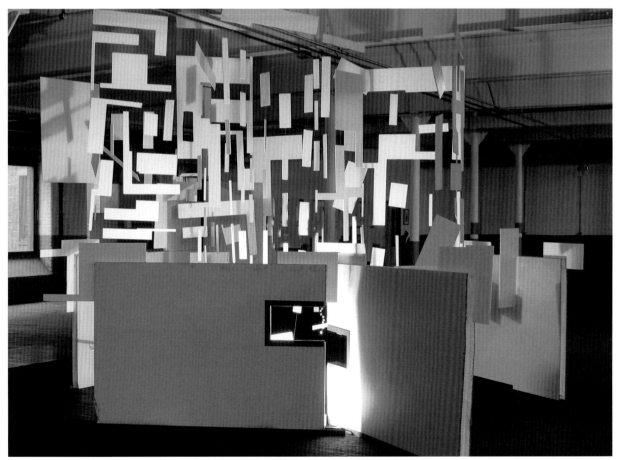

4.

4. Collage installation, foamcore, Formica, wood, and fishing line, by Angela McGuire.

Artists on Intuition "The intuitive way in which I work allows me to build up a painting in layers so that each painting develops its own unique history. For me, a painting comes into being through mark-making without a preconceived notion of what the marks will be. Relying on intuition lets a painting become a visual representation of my thoughts and feelings. It allows me to express a sense of something beyond the physical—something more emotional, in tune with what is at the heart of being human. It is my intention to allow for ambiguity so that a viewer may be able to enter into an unexplored, visual world that maybe they can relate to and become a part of." Luke Cavagnac

Opposite page: *Drop of Water*, simple composition, acrylic on wood, by Luke Cavagnac.

Stick With It!
THE SELF-CRITIQUE PROCESS

The self-critique process involves setting aside time to look at your artwork and to think about what's working and what's not, as well as generating new ideas and techniques.

HOW TO GET THE MOST OUT OF THE SELF-CRITIQUE PROCESS

Schedule one hour for a self-critique session at least once per month. You need to set aside time for your self-critique and to make sure that you keep the process of evaluating your work separate from the process of creating it.

Establish specific goals for your self-critique session. The goals you set may range from broad considerations, like deciding on what themes or visual ideas you want to pursue, to fine-tuning methods you can use in creating works of art.

The focus for your self-critique may change from session to session, but it's important to have one and to plan to address that focus in each session.

Avoid using the self-critique process as a way of judging the market value or popular appeal of your art. Your thoughts and feelings about your art should be the only criteria that matter in this process. Remember that the main point of self-critique is to enrich your experience of making art, and that is always going to be your true bottom line!

Beyond the Horizon: Challenging Your Imagination

CHAPTER FOUR

Have you ever found yourself stuck in a rut, thinking, "I don't want to draw the same old things again," or just feeling uninspired about your art? Becoming bored with or stagnant in your work is often the result of uncreative repetition—doing the same still life over and over, choosing the same palette or techniques, or always setting up in your studio the same way. The projects in this chapter are geared specifically toward helping you get out of your rut or over your artist's block. They will show you how to find inspiration by working with nontraditional subject matter; rethinking your approach to traditional modes of expression, like self-portraits and figure drawing; or trying completely new techniques, like drawing with candle smoke. Each project and exercise encourages you to invent new and imaginative visual possibilities for your art that can uplift your creative spirit.

The exercises in this chapter are not necessarily more advanced than those that have come before, but you should be prepared to experiment with new ideas and be open to accepting the challenge of "I *can* make something interesting out of nothing!" By refusing to allow yourself to be bored, you can boost your confidence and give yourself a shot of renewed enthusiasm for making art.

DRAWING FROM NOTHING:
THERE'S NO SUCH THING AS A BORING SUBJECT

This project requires that you move away from your favorite drawing subjects and begin to look at and draw things that would normally escape your notice. The challenge here is to find value in those objects that don't seem appealing, or are even outright boring, and to make them interesting by virtue of what you do with them. These exercises are a good resource for times when you are feeling blocked and need to break out of that mood by getting started on something right away. To do this, you need to assume that subjects to draw are all around you—the wood grain on your drawing table, the flaking paint on the wall, or the light reflected in a drinking glass. These everyday subjects can be transformed into interesting pieces of art. You can use any techniques and mediums you choose for this exercise.

Materials

→ Newsprint and bond paper
→ Charcoal
→ Pencils
→ Erasers
→ Pens and markers
→ Crayons and pastels
→ Additional materials of your choosing

Exercise 1. Subjects to Draw Are Everywhere

Start by taking a good look around you, allowing your eyes to settle on details that are often overlooked, like cracks in the wall or a pattern of stains on the floor. Tape off a rectangle around your subject to help you focus your attention on the area you want to draw. Try to forget about what the object or pattern *is*, and simply draw what you see inside the rectangle—shapes, colors, patterns, textures, etc. Work with a simple medium, like graphite pencil or stick charcoal, and make at least five to ten sketches of this area. These sketches can vary from detailed renderings to complete abstracts, and you should try to make each one somewhat different from the one before.

You may want to try the 30 Sketches in 30 Minutes idea (see page 51) with this exercise so as not to get stuck thinking too much about what to draw. Though the purpose of this exercise is more to gather ideas than to make finished drawings, some drawings you make at this stage may stand on their own.

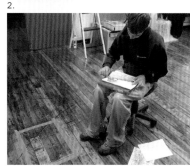

1.

2.

3.

Exercise 2. Drawing What You "See" When You Close Your Eyes

Another source for finding riches in thin air is to close your eyes, "see" what's there, and then try to draw it. We've all had the experience of watching the movement of particles of light that seem to zip around behind our eyelids, but you may not have considered them as a subject for drawing. Like the process of drawing a moving figure, you have to put down your impressions of their overall movement, since you can't make them stand still. Of course, once you close your eyes, you can visualize a whole realm of imaginary shapes, colors, textures that can take off in many interesting directions, but first you have to take the time to meditate with your eyes closed to be able to see what's there.

1. Sketches made from an ordinary wood floor.
2. Sketching part of an ordinary wall.
3. Sketching part of an ordinary wood floor.

4. Drawing made looking at the wood grain on the floor, charcoal on paper, by Matthew Yee.
5. Drawing made from a vision seen with eyes closed, charcoal and acrylic on paper.

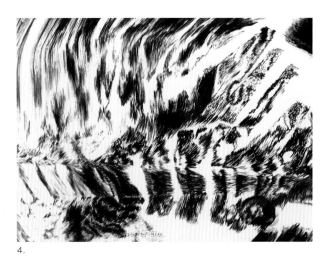

4.

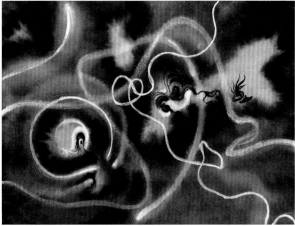

5.

Exercise 3. Drawing What You Can't See

Drawing what you can't see also requires a form of meditation that helps you, as an artist, to envision those things that are invisible. This does not mean that you necessarily need to study the discipline of metaphysical meditation, but rather that you make the leap from the safety of drawing only what you see to experimenting with drawing what your other, nonvisual senses tell you. For example, what do the smells of a spring day *look* like? What does the sound of a meadowlark look like? Or that of a whale, a coyote, or a beetle? And what about the tastes of ginger or coriander? The feel of wet sand? And so on. Keep in mind that this is not a game, requiring you to illustrate what each of the human senses look like, but an opportunity to expand your subject matter beyond the physical world. Since there are no archetypal images that exactly match the challenge of drawing what you can't see, you have the freedom to interpret these elusive ideas in any way you choose.

1.

2.

1. Drawing the feel of leather; ink, pastel, and acrylic on paper.

2. Drawing the bitter taste of lemons; pastel and acrylic on paper.

3. Drawing the sounds of waves crashing onto rocks; charcoal, ink, and pencil on paper.

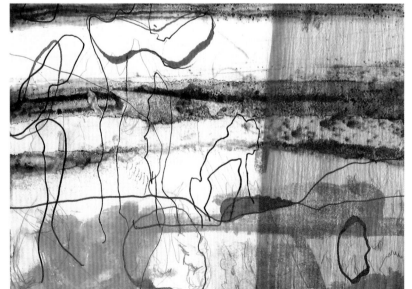

3.

4.. Drawing developed from a section of an orange, watercolor on paper.
5. Drawing developed from a section of a seashell, watercolor on paper.

4.

5.

Other Exercises to Try

➜ Sometimes it's the details that matter. You can take advantage of this idea by focusing on a specific detail of an ordinary subject, like the top of an orange or a close-up of a seashell, and drawing it as a fully realized composition.

➜ Drawing from nothing is a perfect project for sketchbooks. It can be done anywhere, with any materials. This form of observation-based doodling can jump-start your imagination and free you to come up with more possibilities for your art.

Don't forget to select examples from these exercises to put into your Like, Dislike, and TBC portfolios, and work on ideas in your sketchbook for future reference!

OUT OF THE SHADOWS:
COLLECTING SHADOW FORMS FOR YOUR ART

This project explores the creative possibilities of using shadows as the primary subject matter for your drawings and paintings. The process of observing and drawing shadows is an important part of rendering the details of landscapes, still lifes, and figure studies, but shadows are seldom treated as the artist's main subject matter. These exercises require searching for a variety of shadows, indoors and out, and tracing the shadows' outlines to be used as the subject of drawing, painting, and collage. The mission of the "shadow hunt" is to sketch as many different kinds of shadowy shapes as possible without necessarily thinking about how they will be used in your work.

Materials

→ 18 × 24 newsprint or white bond paper
→ Soft, compressed charcoal sticks or charcoal pencils
→ Marker pen (e.g., Sharpie)
→ Additional materials of your choosing

1.

Exercise 1. The First Shadow Drawings

First find interesting shadows outdoors, and sketch their outlines on separate pieces of paper. Consider making your sketches at a time of day when sunlight is most intense overhead or when the sun casts long, exaggerated shadows as it nears the horizon. You are making these shadow outlines to develop them later into drawing, painting, or collage compositions. You can record many overlapping shadows on one piece of paper or use individual shadows as your focus, but you should have a total of at least twenty separate pages of shadow sketches before you go on to the next stage of this exercise. Remember that at this stage, you are just gathering shadow samples and don't need to compose or elaborate on any of these sketches. Keep in mind that your shadow sketches may also include rubbings from the textures of the ground below the shadow you are tracing. Some of these shadow sketches may stand on their own, while others can be developed in subsequent exercises.

2.

3.

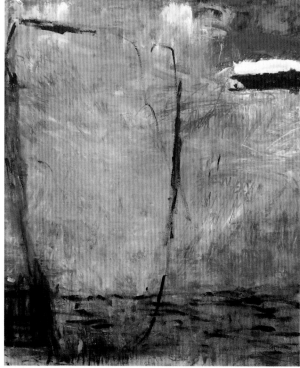

1. Shadows of trees cast on snow.

2. Shadow drawing developed from initial sketches, charcoal on paper.

3. *Nocturne*, shadow painting, oil on canvas, by Suk Shuglie.

Exercise 2. Creating New Shadow Compositions from Your Sketches

Once you have made at least twenty pages of shadow drawings, look through them and select three or four that you'd like to work with in this next exercise. Choose those drawings that seem to lend themselves to a direct application of black-and-white or color mediums. You may find some interesting shadow outlines that can be developed by either adding paint or charcoal to negative (empty) space around the traced outlines or working with your medium into the positive (solid) shapes inside the traced shadow lines. One of the objectives of this exercise is that of developing interesting compositions that emphasize the dramatic character of these unusual forms.

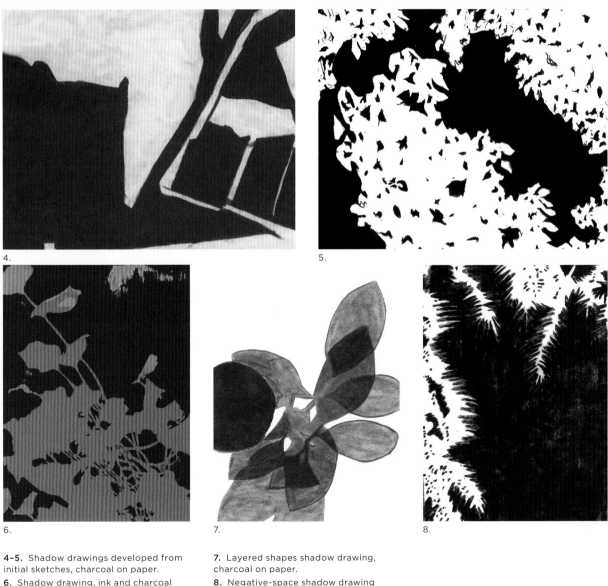

4.

5.

6.

7.

8.

4–5. Shadow drawings developed from initial sketches, charcoal on paper.

6. Shadow drawing, ink and charcoal on paper.

7. Layered shapes shadow drawing, charcoal on paper.

8. Negative-space shadow drawing developed from initial sketches, charcoal on paper.

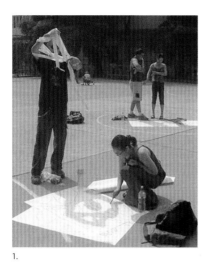

1.

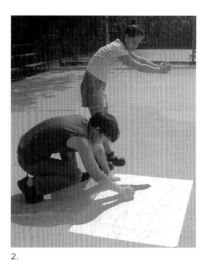

2.

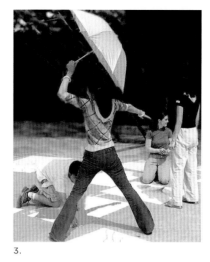

3.

4.

Exercise 3. Shadow Drawing with a Partner

The shadow drawing is also well-suited for working with a partner. In this exercise, each partner will take a turn drawing the shadow outlines and, alternately, posing to create the shadows for his or her partner. In other words, the person drawing the shadow outline will direct his or her partner to pose in specific ways to cast the most interesting shadows on the paper—"Move this way," "Bend your arm a little more," "Reach out at more of an angle," and so on—until he or she sees a shadow to trace. The shadow sketches that you make while directing your partner to pose are the sketches that belong to you. Each partner takes a turn posing for shadows and tracing shadow outlines until he or she has about twenty separate shadow sketches. Once you have your stock of shadows, you can begin working into these sketches with any materials or techniques you select.

5.

6.

1-4. Students posing to create shadows for one another.
5. Negative-space shadow drawing with color, ink, pastel, and watercolor on paper.
6. Textured shadow drawing, charcoal on paper.

Exercise 4. Creating Unique Shadow Drawings Indoors

You can create your own shadows indoors by setting up clip lights attached to chairs, or spotlights on stands. To get the most intense shadows, you'll need to use very bright bulbs or spots that are 150 to 250 watts. The advantages of an indoor setup are that you can regulate the direction and intensity of light to modify the shapes and values of the shadows. This method also lets you use many different kinds of objects or figures to create multiform shadows that overlap one another. You can also work with a partner using indoor lighting to cast shadows, as suggested in Exercise 3.

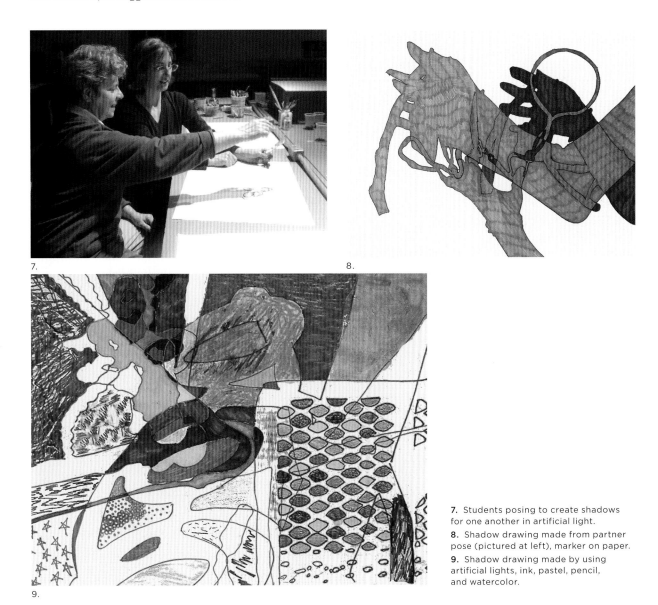

7.

8.

9.

7. Students posing to create shadows for one another in artificial light.

8. Shadow drawing made from partner pose (pictured at left), marker on paper.

9. Shadow drawing made by using artificial lights, ink, pastel, pencil, and watercolor.

Other Exercises to Try

Don't forget to select examples from these exercises to put into your Like, Dislike, and TBC portfolios, and work on ideas in your sketchbook for future reference!

→ Sometimes your shadow drawings will remind you of a figure, an object, or a landscape that you can develop in a way that makes this form more prominent in the final piece.

→ Use your study of shadows to enhance your observation skills and technical understanding of shadows for drawing and painting objects, figures, and landscapes.

MAPPING YOUR MIND:
USING OLD MAPS FOR INSPIRATION, CREATING NEW MAPS FOR CONTEMPLATION

This project is about using maps, charts, and diagrams as prepared surfaces for drawing, painting, and collage. Maps can be a wonderful source for ready-made compositions because their shapes, lines, and complex structures can inspire many different ideas to explore. You can build new images over those found on maps as well as use maps as components in other collage and painting projects. You can start with new maps or find vintage maps, tables, or diagrams by poring over old magazines, road atlases, books, or publications. These maps can be used directly, or scanned or copied for use in these exercises.

Materials

→ New or old road maps, charts, and/or diagrams from books and magazines
→ Water-based paints
→ Brushes
→ Ink
→ Charcoal and pastels
→ Additional materials of your choosing

Exercise 1. Work with the Shapes in Your Map

Start by choosing a map that has shapes and colors that interest you. Think of this map as a type of coloring book, and use lines that may denote highways or boundaries as areas in which to add color or as collage elements for creating a completely new composition. Try using your collage materials and paint to interact with the lines, colors, and forms on the map, as if they belonged together. The objectives of this exercise are to further your intuitive understanding of composition and to broaden your ideas about the creative possibilities that lie within everyday things.

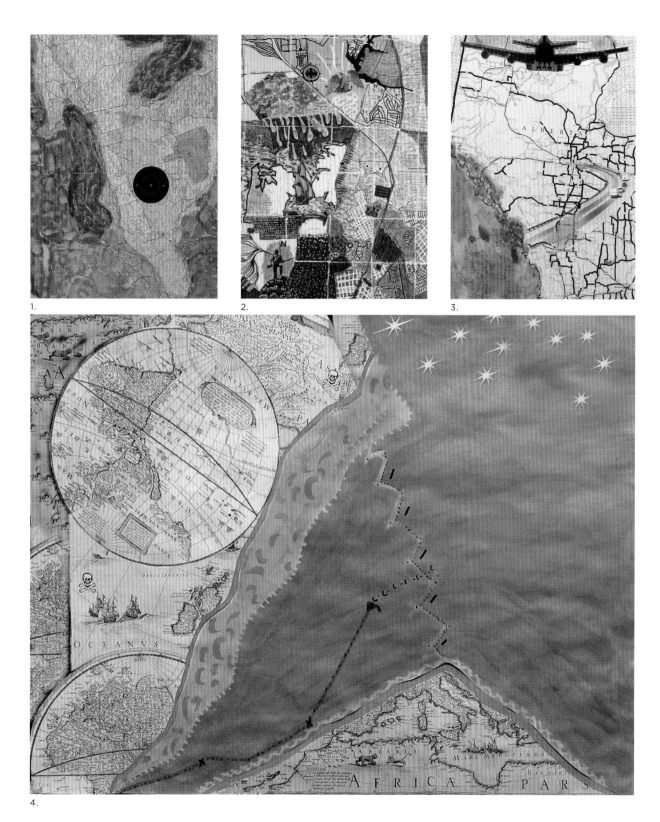

1–3. Painted and collaged maps, mixed media on paper.

4. *Conquest Map*, acrylic and mixed media, by Angela McGuire.

1. Isolating a detail of a map to work from.
2. Painting made from the detail of the map, acrylic on paper.

2.

1.

Exercise 2. Zoom In on Your Map

Zoom in on a section of a map that you think has particularly interesting shapes, colors, or textures, and mask it off with tape. Using this section as a starting point, consider options like simplifying the map's design, and drawing or painting that design onto another piece of paper or canvas. You can enlarge this section and reconfigure the shapes, colors, and textures to fit your own compositional ideas. Remember that the map is just a resource that can be manipulated in any way that inspires you.

Exercise 3. Create Your Own Maps of Time and Space

Create compositions that represent dreams of journeys through space and time. I'm suggesting this subject as something you would represent abstractly rather than try to illustrate literally. This is a rather ambitious, subjective theme that can take you almost anywhere, using virtually any materials. Even so, try to stay focused on the inspiration that the maps have given you and let your intuition lead the rest of the way.

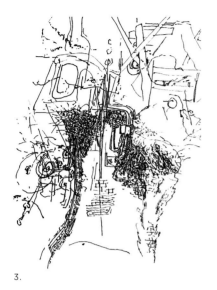

3.

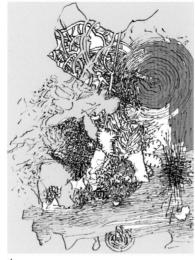

4.

5.

Exercise 4. Make Maps of Your Life

Make your own maps based on important places, events, and moments in your life. Put together a list of several significant moments, and then construct a visual diary in the form of a map that shows how you got from one to the next. A family tree is one form of this kind of life map. You might include photographs, letters, or text, and other scrapbook materials to make up a collage, as well as self-portrait drawings or anything else that represents your travels through life.

3. Map of a dream, ink and marker on paper.
4. Map of Subconscious Mind, ink on paper.
5. Map of a dream, acrylic on paper.

6. *Personal Map*, mixed-media collage, by Alexandra Brault.

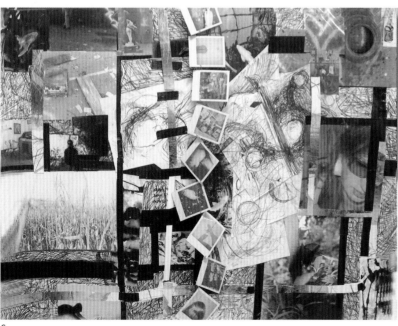

6.

Other Exercises to Try

→ Pick a specific object (e.g., a plant, household tool, or the human figure), and use it as the basis for a map. Follow the form and idea of a map, and diagram the parts of your object as if you were actually traveling over it, through it, or heading toward it as a destination on a trip.

→ Use a map as a pattern motif or template by reworking its surface using similar materials, colors, and marks that imitate its design. Add a layer of new lines, forms, and diagrams that seem to continue the map in a more abstract way. It may be easier to see the separate patterns in the map by turning it upside-down so that you can't read the text.

→ Mix and match parts of different maps, and combine them in a collage. Try making them fit seamlessly, as if you were mapping a completely new country or place.

Don't forget to select examples from these exercises to put into your Like, Dislike, and TBC portfolios, and work on ideas in your sketchbook for future reference!

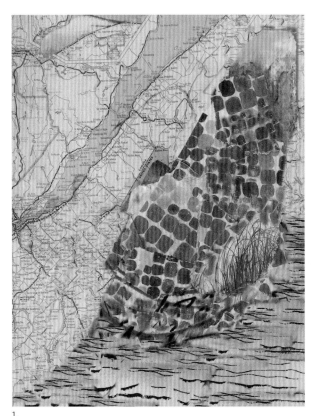

1.

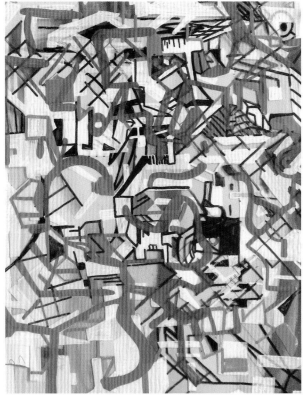

2.

1. Patterned map, mixed media on paper.
2. Patterned map; ink, pastel, and marker on paper.

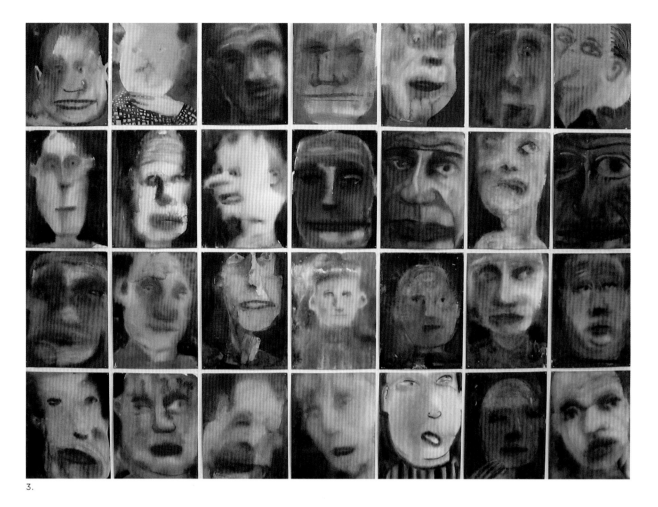

3.

SELF-PORTRAITS: NEW APPROACHES TO PICTURING YOUR MANY FACES

Self-portraits are a unique and fascinating subject for artists and art audiences alike. For the artist, the appeal of a self-portrait is the challenge of painting your physical appearance and something of the intangible "real you" under the surface. For the viewer, there is a kind of voyeuristic fascination with trying to see through the physical appearance to discover the nuanced characteristics hidden within the portrait. Rembrandt produced scores of self-portraits throughout his life that allow us to observe both changes in his physical appearance and the evolution of his artistic and emotional psyche. Many artists shy away from doing self-portraits because they assume that their portrait must be an accurate rendering of what they look like—but that is simply not true. The following exercises use unconventional strategies for creating self-portraits that allow you the freedom to choose how to see yourself—beyond the conventions of traditional portraiture. The thing to remember is that there are virtually no rules for what a self-portrait should look like or how it should be made.

3. *Mood Swings*, self-portraits, acrylic on paper, by Frank Ozeriko.

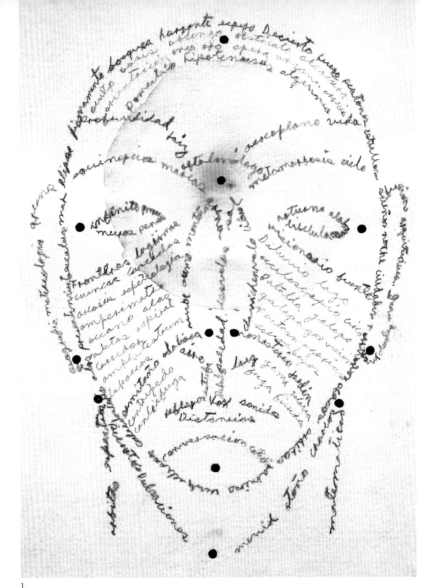

1. *Self-portrait*, pen and ink on watercolor paper, by Carlos Estevez.

2. *The Fox*, self-portrait, colored pencil on paper, by Eduardo Caminos.

3. Self-portrait as a musical instrument, ink on paper.

4. Self-portrait as Batman, acrylic and ink on paper.

5. *Inside-out*, self-portrait, acrylic and ink on paper, by Scott Beluzo.

1.

Materials

→ The materials you use to do your self-portraits are entirely up to you— that is, your choice of drawing paper, canvas, charcoal, pencils, paints, as well as collage materials and techniques.

Exercise 1. Imagine Yourself as an Object, an Animal, or a Superhero

A self-portrait is not necessarily a photorealistic image of your face looking straight into the camera or pensively off into space—*boring*! Instead, you can start your portrait by imagining yourself as something you're not—let's say, a tuba, a trash can, an iguana, a fox, or an unshaven superhero dreaming of saving a damsel in distress. Here the point is to consider aspects beyond your physical appearance and to imagine what it would be like to take on another persona.

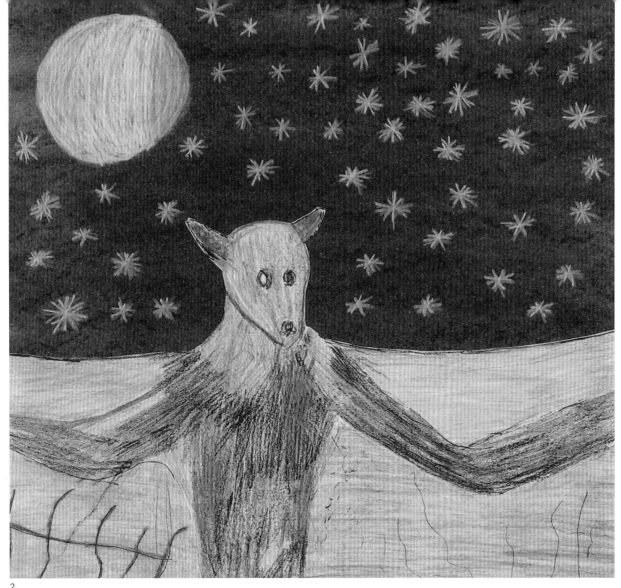

2.

3.

4.

5.

Exercise 2. Use Your "Stuff" for a Self-Portrait

The things that belong to you—your photographs, notes, and letters, the things you collect, etc.—can be stock materials for a collage self-portrait. Here, again, there are no strict rules about what this portrait should look like, though you should consider strategies that will help you through the process of building this collage; these include keeping the portrait idea in the back of your mind (where your intuition is) so that this piece is not overly literal or self-conscious. Also, consider interpreting your personal photographs and memorabilia symbolically rather than merely assembling them into the collage's composition.

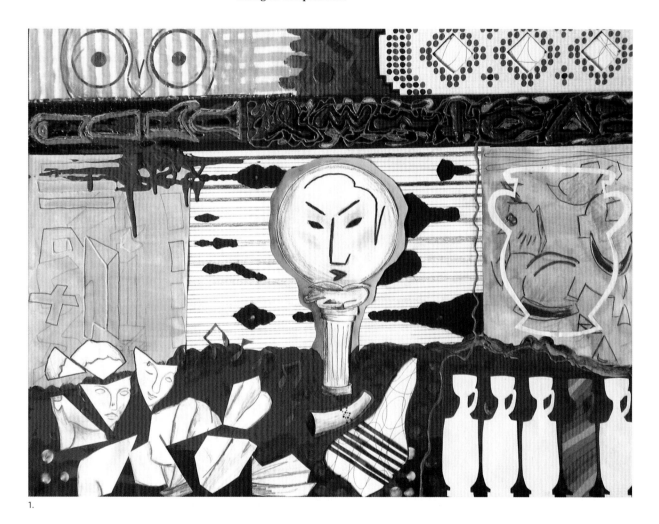

1.

Exercise 3. Make a Caricature of Yourself

One lighthearted approach to self-portraiture is to do a cartoon or caricature of yourself. You needn't be a skilled cartoonist to do this—you just need to bring your sense of humor to bear in creating your portrait. Another key is to freely exaggerate your features, your mood, and your expression—have fun with the image you have of yourself!

1. Self-portrait, mixed-media collage on paper.

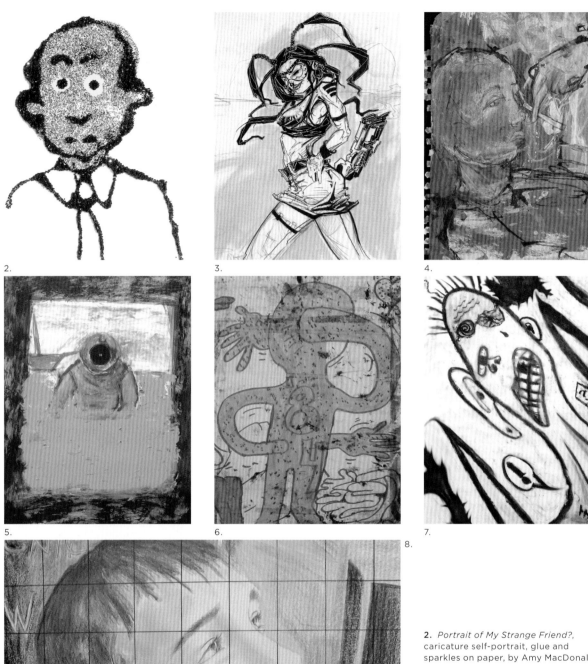

2. *Portrait of My Strange Friend?*, caricature self-portrait, glue and sparkles on paper, by Amy MacDonald.

3. Caricature self-portrait as a punk-rock dancer, ink and acrylic on paper.

4. Caricature self-portrait as a heavy drinker, mixed media on paper.

5. Caricature self-portrait as a deep-sea diver, mixed media on paper.

6. Caricature self-portrait from a dream, markers and ink on paper.

7. Caricature self-portrait showing inner emotions, charcoal on paper.

8. *Trapped in a Grid*, caricature self-portrait, colored pencil and graphite on paper, by Scott Beluzo.

Exercise 4. Make a Self-Portrait in the Manner of an Art Movement

Try interpreting your portrait in terms of an art movement—as a cubist drawing, a surrealist painting, or a Pop Art portrait, etc. Because this process involves borrowing the basic concepts and outer structure of an art movement, you'll need to study some art history in order to make this imitation convincing. Your parody of another art form should have a bit of wit and nuance in order for it to be most effective.

1. Self-portrait done as a cubist composition, watercolor on paper.
2. Dada-style self-portrait, acrylic on paper.
3. Self-portrait as a god from Greek mythology, mixed media on paper.
4. Surrealist self-portrait, charcoal on paper.
5. *Looking In*, self-portrait, acrylic and ink on a mirror, by Anne Marie Belden.

Other Exercises to Try

→ Using a mirror to see your reflection, draw your face and upper torso using "blind contour" line drawing techniques. Blind contour simply means looking only at your reflection in the mirror and not stopping to check your drawing on the paper as you go.

→ Make notes in your sketchbook about different self-portrait ideas— as a buffalo, a Greek god, a building, and so forth.

→ Go to an art gallery or museum to study other artists' self-portraits, and make sketches and notes on what aspects of their work interests you.

Don't forget to select examples from these exercises to put into your Like, Dislike, and TBC portfolios, and work on ideas in your sketchbook for future reference!

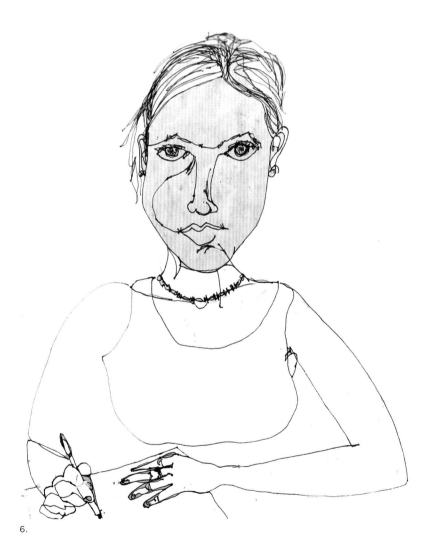

6.

6. Contour drawing, self-portrait, ink on paper.

DRAWING WITH SMOKE:
DIRECT DRAWING USING SMOKE AND FIRE

Smoke drawings are one of the many experimental processes used by the surrealists and other artists to create beautiful, evocative effects of depth and space in their pictures. It's another approach that deemphasizes control and elevates intuitive discovery. The marks left by the smoke are delicate but will form a rich velvety black as you continue to layer them. The effects that you can achieve with this method are quite unique and not likely to be reproduced by some other method. Drawing with smoke is an intriguing process; it also demonstrates that you have an abundance of materials available to you in the nooks and crannies of your home that you probably didn't think could be used for art.

Materials

→ Heavyweight drawing paper (Stonehenge or Rives, if you can afford it) or foamcore (polystyrene) boards
→ Taper candles
→ Spray bottle (filled with water)
→ Vine and compressed charcoal
→ Charcoal pencils
→ Assorted erasers (e.g., kneaded, plastic, gum)
→ Leather gloves
→ Bucket of water or fire extinguisher
→ Additional materials of your choosing

Exercise 1. Making Smoke into Art

Begin by using the candle to create long trails of marks all over your paper. Remember not to hold the flame too close to the surface or stay in one spot for too long. This process can be executed most effectively by tacking your paper to a drawing board and angling the paper downward while you move the candle back and forth across its surface. Be careful not to put the flame too close—you don't want to burn up your art before it's made! Keep this up until you've covered a substantial part of the surface with smoky traces.

Try rotating your paper every so often so that the marks cross each other. You might draw from an object or from your imagination. Then, begin drawing with the flame once more, and add another layer of smoke. Keep going back and forth, from the candle to your other materials, until the drawing feels complete.

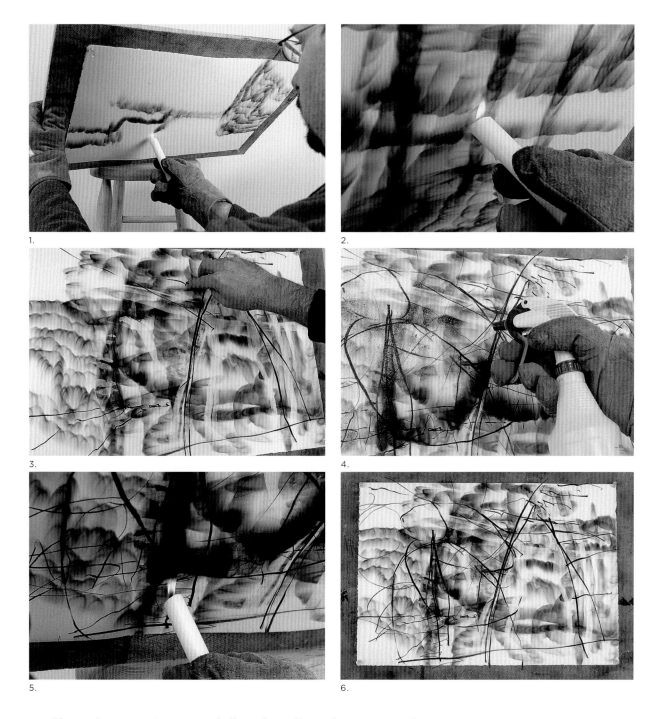

1.

2.

3.

4.

5.

6.

The smoke can create a range of effects, depending on how you move the candle; try changing the direction of the movement, layering the marks in different areas, and holding the flame at different distances from the page. You can also work back into the smoke with charcoal and erasers—kneaded erasers are great for dabbing, smudging, and swiping through the smoky layers.

1. Drawing with smoke: the first stages—positioning the paper and candle.

2. Layering smoky traces on the paper.

3. Using erasers and charcoal with smoke layers.

4. Misting water into smoke drawings to change values and textures.

5-6. Adding additional layers of smoke, tea, and charcoal to a wet drawing.

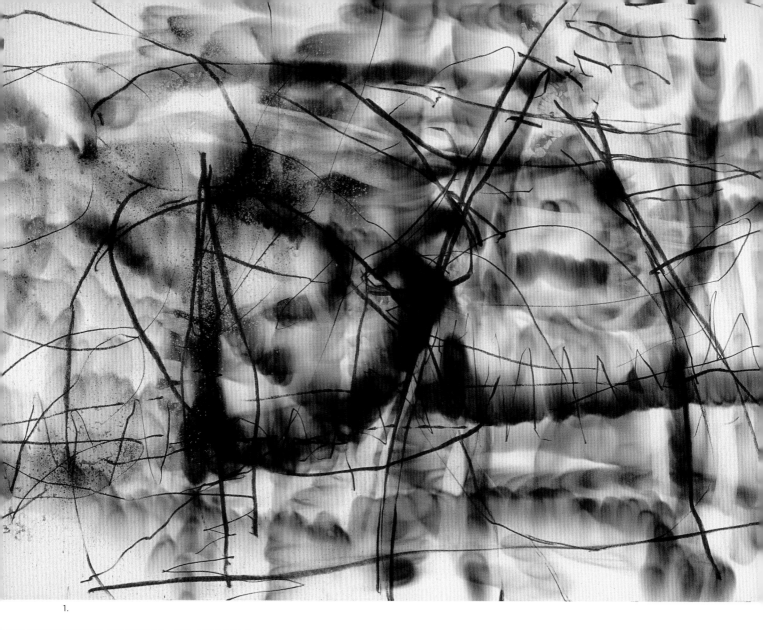

1.

SAFETY PRECAUTIONS!
There are some obvious hazards in using a lit candle to stain raw paper, and it is important to take all necessary safety precautions. The first decision you have to make is whether to employ this process indoors or out. I suggest that you do this project outdoors, away from other flammable materials, and sheltered from the wind. If you choose to do smoke drawings indoors, you need to be sure that all flammable materials are well away from your work area and that you have either water or a fire extinguisher at hand. A good precaution is to set up a tray of water that's bigger than your paper so that you can dunk the drawing in it if your paper should catch fire. Ideally, you should set up this project in a place that has excellent ventilation and concrete floors to minimize the dangers involved. Regardless of working indoors or out, you should wear leather gloves so as not to get burned by the flame or molten candle wax. If possible, do this project with a partner who is watching out for any fire hazards.

Exercise 2. Staining Paper with Washes, Ink, and Tea

Start another smoke drawing by first staining the paper with acrylic or watercolor wash; ink washes and tea or coffee stains also work well. When the background wash is dry, you're ready to move on. Then repeat the process from Exercise 1. You might use the shapes or patterns created by the stains to guide the marks you make with the candle and other materials.

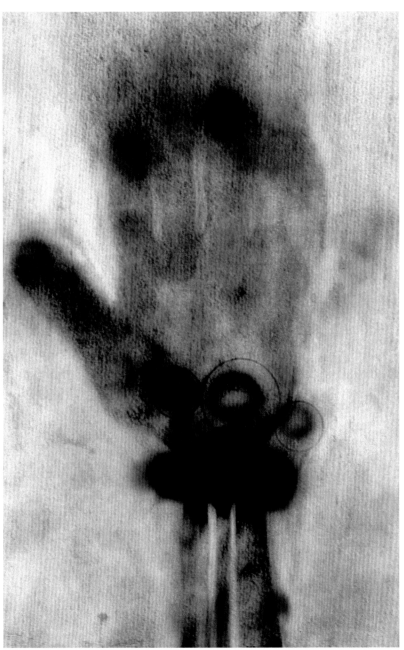

2.

1. Opposite page: Finished smoke, tea, and charcoal drawing, by Christopher Willingham.

2. *Untitled*, smoke and tea drawing, by Mark Kelly.

1.

1. *Wasteland*, smoke and mixed media on paper, by Dean Nimmer.

Exercise 3. Add Water to the Mix

Experiment with the effects of water on this process by spraying some parts of your paper before you begin drawing with the candle. Notice how the wet areas resist the scorch and soot marks. After you've built up some layers, spray parts of the drawing, and let the smoke and charcoal marks blur, drip, and run. Then work back into the drawing with another layer of marks.

Other Exercises to Try

→ Use pieces from your portfolios as the background for your smoke drawings. Use some of them as compositional guides, and trace over them with smoke marks; work randomly over some of the others.

→ Mask off some areas of your paper before you begin drawing; use tape or removable scraps of paper that will resist the smoke or that can be removed later to reveal the untouched surface below. You might set these up in a design or pattern that will contrast with the more organic and sensuous marks you made with the smoke and other materials.

Don't forget to select examples from these exercises to put into your Like, Dislike, and TBC portfolios, and work on ideas in your sketchbook for future reference!

GESTURE DRAWING:
DRAWING FIGURES AND OBJECTS IN MOTION

Gesture drawing can be a valuable technique for loosening up both hand and mind in your art practice. Many artists use gesture drawing as a warm-up before they move on to a different, tighter mode of working, in the same way that actors, dancers and musicians warm up before they begin a performance. In addition, gesture drawing is a valuable technique in itself, requiring as much concentration and skill as any other form of art practice. The fact that gesture drawings look like they're made of scribbles and easy dashes of paint belies the difficulties of this process. The real challenge in using this technique is to set aside your prejudices about representing a figure realistically, in favor of seeing and representing the way a form or figure moves. This means that the main purpose of gesture drawing is to describe what a form or figure is *doing* instead of what it looks like when still.

Materials

➡ Generally speaking, you want to keep the materials you are using for gesture drawing simple and easy to use. I recommend an inexpensive paper like newsprint—because you can go through many sheets doing quick gestures—and soft, square sticks of charcoal to draw with.

➡ 18 × 24 newsprint (use cheap paper for gesture drawing)

➡ Assorted drawing and charcoal pencils

➡ Felt-tipped pens

➡ Vine or stick charcoal

➡ Assorted erasers

➡ Additional materials of your choice

Exercise 1. Basic Gesture Studies of a Model

Gesture drawing is a technique that definitely requires you to trust your intuition to go with the flow of movements that you see and not get hung up on having to render the details of a form. Gesture drawing requires that you find a model who can follow some simple directions and is also willing to freely move around and improvise. The primary task for the model is to be *doing* something that involves a repeated movement while you record that movement in your drawings.

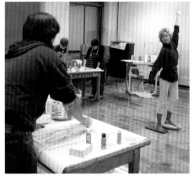

2.

2. Model doing a repeated-activity gesture pose.

In the first part of this exercise, have the model start by making a repeated motion, like swinging her arms from side to side or up and down, and to continue that motion for about one minute. Once the model has established a rhythm of movements, you begin to sketch those movements with your charcoal until you feel in sync with the actions of the model. Continue this process of one-minute action poses for at least thirty minutes. The sketches made in this first group can be superimposed on top of one another without worrying about how any individual drawing appears. Remember to look only at the figure and not at your paper during the one-minute drawing time.

1. Gesture drawing emphasizing continuous movement, charcoal and ink on paper.
2. Gesture drawing describing an ongoing movement.

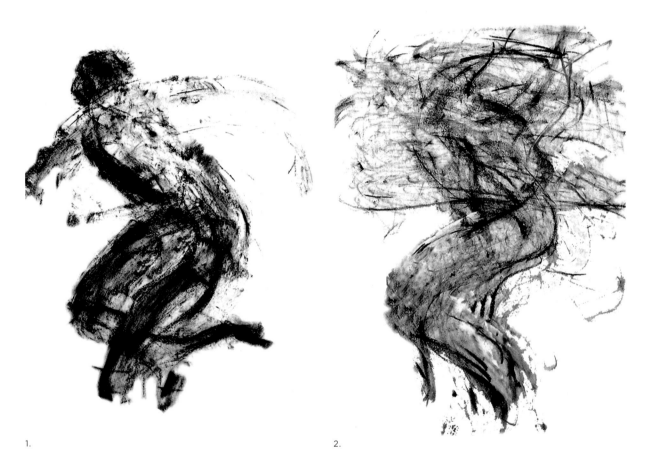

1.

2.

Exercise 2. Capturing the Model's Movement

In the second phase of gesture drawing, try having the model perform an everyday action, like mopping the floor, or an athletic action, like swinging a tennis racquet. Have the model repeat this action, as you did in Exercise 1, but freeze the action in a position at the end of a movement and hold that position for an additional thirty seconds.

While the model is holding this pose, draw his or her figure as if it were still moving. The idea is to show the traces of where a movement came from and where the movement is going. This process involves some exaggeration of what you see to include the invisible lines that describe the whole action that it constitutes, e.g., swinging a tennis racquet or mopping the floor while keeping these gestures as free and spontaneous as possible.

Exercise 3. Gesture Drawing with Brush and Ink

Next, use brush and ink and mixed media to experiment with different combinations of action brush strokes and flowing lines in your gesture drawings. A brush is a versatile medium for capturing motion, and you may prefer the feel of it to that of pencils or charcoal. Using a brush can help the spontaneity and flow of the marks and allow you to capture a gesture with a real economy of means. Some artists prefer to use a bamboo brush for gesture drawings, but any brush can work as long as you are comfortable using it.

Using a brush and either ink or liquid paint, make a sequence of quick gestures that describes a pose with no more than ten brushstrokes. These few strokes reduce the gesture to its simplest form and capture the essential aspects of the pose. The poses for this exercise must be about thirty seconds or less in order to avoid the tendency to start filling in the figure with extra lines and shapes.

Capturing the essential movement of a pose in only a few lines requires that you try this process over and over again to get it right. Once you've made at least twenty gesture brush drawings, try reducing the process to only one or two brushstrokes that capture the spirit of movement in the pose.

3. Ten-second gesture drawing to depict essential movement, brush and ink.
4. Gesture drawing using minimal brushstrokes to describe the pose.
5. Gesture drawing using only three brushstrokes to describe the pose.

3.

4.

5.

Exercise 4. Advanced Gesture Drawing

Once you are comfortable with the gesture drawing process, you can start working on longer poses with the figure that retain a quality of movement within the pose. By longer, I mean no more than two- to five-minute poses that keep you working quickly. You may also want to bring in other mediums, such as watercolor or gouache, that work well with this spontaneous process. You can try combining brush methods with charcoal or other drawing tools for the longer poses. Remember that the movement of the figure is still the emphasis in gesture drawing, and that you need to avoid slipping back into old habits of meticulous rendering that take you away from the point of this exercise.

1. Gesture drawing describing both form and movement of the figure, charcoal on paper.
2. Gesture drawing describing both form and movement of the figure in a few brushstrokes, watercolor on paper.
3. *Untitled*, combining gesture drawing with a longer pose to capture both movement and form of the figure, ink-wash drawing, by Amy MacDonald.

1.

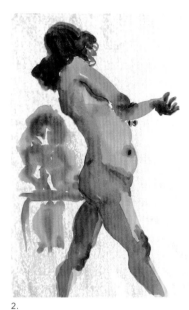

2.

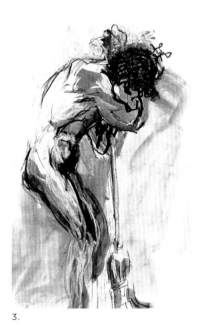

3.

Exercise 5. Gesture Drawing Without a Subject

You can also work with pure gesture marks abstractly, without having a visible subject to study. In other words, the subject of these abstract gesture drawings is *movement itself*, rather than a figure or object. Since movement is partly an abstract phenomenon, you can approach this idea in much the same way that you did with the exercises in Automatic Drawing, or Drawing from Nothing—just begin drawing and let your intuition take it from there.

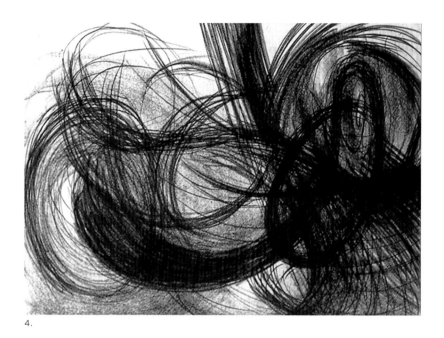

4.

Other Exercises to Try

→ Make studies of something that moves on its own, like your pet, things that blow in the wind, passing cars, etc. If your model is a creature that is moving continually, like a fish, watch the movement of the fish for several minutes before attempting to draw it.

→ Gesture drawing can also be used to describe the movements of form, line, and texture that are present in any still subject. Try making drawings of the motion implied in the curves of a vase, the movement of the textures of sand on a beach, or anything that catches your fancy.

→ Gestures are perfect exercises for your sketchbook—they can be done anywhere, depict anything quickly, and all you need is a pencil or a pen.

Don't forget to select examples from these exercises to put into your Like, Dislike, and TBC portfolios, and work on ideas in your sketchbook for future reference!

4. A "pure" gesture drawing made by simply moving in different rhythms and speeds, charcoal on paper.

5. Gesture drawing of a fish in motion, charcoal and brush-and-ink on paper.

6. Gesture drawing from imagination of a bee in motion, charcoal and watercolor on paper.

5. 6.

Artists on Intuition "The role of intuition and directed contemplation in my art practice is to accept the nature of impermanence, chance, and change. The goal is to reduce the interference caused by an overly self-conscious control of natural process in seeing and making. My belief is that, by accepting and responding to the transformative nature of process and suspending expectations about outcomes, I can achieve greater clarity and discovery in the work."
Christopher Willingham

Opposite page: *Metropolis*, ink and charcoal on paper, by Christopher Willingham.

Stick With It!
ACTIVITIES TO SUPPORT YOUR ARTISTIC ENDEAVORS

It is important to seek out ways to continually spark your interest in making art so that you can feed yourself ideas and bolster your skills. Here are a few proactive suggestions to consider:

Take art classes. Consider taking an art class at a local school, college, or community center, or find out about regional artists' colonies and artists' retreat schools where you can apply to be a student for periods of a week or more. This is a great way to get new ideas, inspiration, and practice, as well as to gain information about techniques and materials and essential feedback on your work. Often, just being around other people who are making art is enough to sustain your own creative momentum. Refer to the list of artists' colonies and residencies at the end of the book for more information.

Go to art exhibitions. Going to see art exhibits on a regular basis is another way to get inspired and consider new directions you may want to take in your own work. This is a good activity to do with a friend or fellow artist because of the dialogue that viewing art naturally sparks. When visiting a gallery or museum, try to look for aspects in the work that stimulate your own urges to make art rather than just looking for what you like and dislike. The point is to become more receptive to the positive impulses that will feed your core creativity.

Attend open studio events. In addition to gallery and museum exhibitions, there are often open studio events. These are hosted by a group of artists who invite the public to come view their art and work spaces. These events are usually held in buildings where numerous artists have individual studios. The greatest benefit of going to an open studio event is that you can meet the artists who produce the work you are looking at. You can learn a lot about what other artists think and feel about their work—feedback that is otherwise hard to come by. It is also intriguing to get an insider's view of an artist's studio, as you get to see what materials they are using and how they've set up their work space. If you don't happen to live in a community that has open studio events, seek out other artists to discuss art and to look at each other's work. You may want to take out a small ad in a local newspaper to find other artists nearby who would like to meet and share with you their passion for making art.

Shared Creating: Working with a Partner or in Groups

CHAPTER FIVE

Working alone in the solitude of your studio is not always the most desirable or productive situation for an artist. From time to time, we all need to share our ideas and get an outside perspective on our art. In addition to receiving constructive feedback on our own work, we can benefit from working on group art projects in which everyone contributes to the process of creating the same painting or drawing. This form of "shared creating" emphasizes the enjoyment of making art while lifting the pressure from individuals for achieving a specific end product. The pleasures that come from sharing the creative process with others can bolster your enthusiasm and reinforce your commitment to making art, as well as improve the quality of your overall artistic experience. The exercises in this chapter are devoted to variations of shared creating that can stimulate your imagination and give you the opportunity to observe how others make use of their creative intuition.

THE EXQUISITE CORPSE:
A SURREALIST EXPERIENCE

The Exquisite Corpse is a term coined by surrealist artists in the 1920s and 1930s to denote the process of several artists working together on a single artwork without knowing what each one was making. The basic concept behind this fun technique is for one artist to begin a drawing and then to conceal what he or she is making from the other artists in the group. Once the first artist has finished his drawing, he covers up most of the work, letting show only about two inches of one side for the next artist to see. The next person in succession continues the drawing using only the minimal clues left behind by the first person's drawing. This drawing is finished after each person in the group has made a contribution to the final product.

Materials

➜ 18 × 24 newsprint, or you may want to use a large roll of white craft paper or butcher wrap (36 inches wide and 20 or more feet long) for larger groups of people

➜ Each person may choose any drawing or painting medium, including charcoal, pencils, pens, markers, crayons, tempera paint, and so forth

Exercise 1. The Setup

The Exquisite Corpse drawing process creates an air of excitement and anticipation within the group, since no one actually knows what the final piece is going to look like. This is a great way of collaborating with a number of people to create unique and surprising drawings.

Opposite page: An abstract Exquisite Corpse drawing made on separate pieces of paper taped together, charcoal on paper.

The setup for the Exquisite Corpse is as follows:

➜ A group drawing can be done with anywhere from two to eighteen participants.

➜ The group can use large sheets of paper, folded down accordion-style into equal sections, so that there is at least one section for each participant. Alternatively, a larger group of people may use a roll of paper long enough to accommodate everyone.

➜ Before starting, the group may want to decide on a theme, such as drawing a figure, a creature, a still life, a landscape, or simply an abstract design.

- One person will start the drawing in his or her section and complete it without revealing what he or she made to the group.
- When this participant has finished his or her section, he or she folds it over to hide the drawing, except for a two-inch strip along the side border, for the next person to see.
- The next person begins to draw by extending the lines, textures, and colors from those showing in the last drawing. Even though the next participant must use this information to begin his or her drawing, he can go anywhere he or she wants with it. In other words, you don't have to guess what the last person's drawing looks like; you can draw whatever is suggested by what you see.
- This process continues by folding or rolling each new section underneath the last one until all the participants have completed work on their secret drawings.

1. The first stage of a design-based Exquisite Corpse drawing, marker on paper.

2. The finished design based on an Exquisite Corpse drawing, markers on paper.

1.

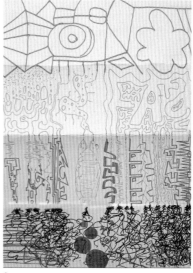

2.

Exercise 2. Using Different Themes

Try choosing an odd or obscure word that you find at random in the dictionary—like the word *infotainment*—and use it as the theme for your Exquisite Corpse drawing. You can also tap into everyone's past experiences by using a theme like "Memory of My Summer at Age 9" or "Portrait of My First Date."

3. The first stage of a figure-based Exquisite Corpse drawing, pencil on paper.

4. Finished figure based on an Exquisite Corpse drawing, pencil on paper.

3.

4.

Other Exercises to Try

→ The Exquisite Corpse can be done on a larger scale, involving twenty people or more. In this scenario, use a roll of roofing paper, tar paper, or butcher paper, and continue to roll it up to hide each person's drawing as you go.

→ The group can decide that each person must use a different set of materials and techniques for his or her part of the drawing. A drawing may start out as a charcoal rendering changing to watercolor, and then to collage, and so on.

→ The group can agree to allow each person to see what the last person did, with the stipulation that the next drawing must be the "opposite" of the one before it.

SHARED DRAWING:
DRAWING ON EACH OTHER'S WORK

Much like the Exquisite Corpse drawing process, shared drawings are intriguing examples of collective creativity that enable each person to make his or her unique contribution to the final product. This form of communal drawing has each member of a group draw directly on everyone else's drawings to create the finished work. In this process, each participant begins a drawing from an observed subject or from his or her imagination, and at regular intervals, all drawings are passed over to the person next in line to continue the drawing where the last person left off. This process continues until everyone in the group has contributed to each drawing; the drawing is finished when it arrives back on the desk of the person who started it.

Materials

→ 18 × 24 newsprint
→ Each person may choose any drawing or painting medium, including charcoal, pencils, pens, markers, crayons, tempera paint, etc.

Exercise 1. The Guidelines

The first shared drawings should have everyone working on the same size paper (18 × 24 newsprint) and using the same medium (charcoal sticks or pencils). Also, everyone should be drawing from observation the same object or figure that is set up in the middle of the group. Here are some guidelines:

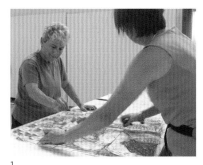
1.

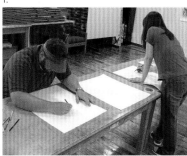
2.

1. Determine how often to switch drawings according to how many people are in the group. In general, you can divide the minutes in one hour by the total number of participants, so that a group of four to six people would change drawings about every ten to fifteen minutes, and groups from seven to twelve people would switch about every five to nine minutes. Groups consisting of more than twelve individuals should be subdivided into smaller clusters of three or four so that the process doesn't get too unwieldy.

2. At the agreed time, members of the group will pass their drawing to the person at their right—meaning that everyone stays where they are and passes their drawing to another person.

3. Once everyone has another person's drawing, they continue to work on that drawing, in whatever medium or techniques they wish, until the next turn comes to change drawings.

4. Each participant can adapt his or her work to another person's drawing style to some degree, while adding unique elements to the work.

5. A shared drawing is complete when it has gone through all members of the group and has returned to the person who began that drawing.

1–2. Students working on each other's drawings in the shared drawing exercise.
3. Class discussing shared drawing project.

3.

Exercise 2. Shared Drawing Using a Theme

The subject for a group drawing does not necessarily have to be an observed object or figure. Instead, the group could decide that the first phase of all drawings will begin with a specific theme in mind, say, a jungle landscape—and then proceed through the same transformation process as in Exercise 1, by passing the work from person to person at regular time intervals.

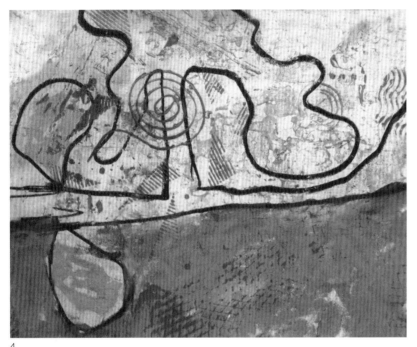
4.

4. Shared drawing between two people, mixed media on paper.

5. An abstract landscape drawing after three students worked on it, mixed media on paper.

6. Completed abstract landscape drawing after six people worked on it, mixed media on paper.

7. Shared creating landscape drawing in process.

8. Shared landscape drawing created by six different people, pencil on paper.

5.

6.

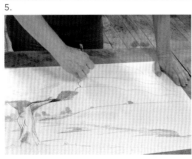
7.

8.

Exercise 3. Shared Self-Portraits

In this exercise, each member of the group begins by working on a facial self-portrait made from memory. After ten minutes or so, everyone in the group passes their self-portrait to the person on their right. After the exchange, each person works with the portrait he was given, trying to modify the image (using erasers and other materials) to look more like his own self-portrait.

1.

2.

3.

1. Student working on shared creating portrait, pencil on paper.

2. Shared creating portrait drawing in process.

3. Shared creating portrait drawing, final stage.

4. Shared portrait drawing created by six different people, pencil on paper.

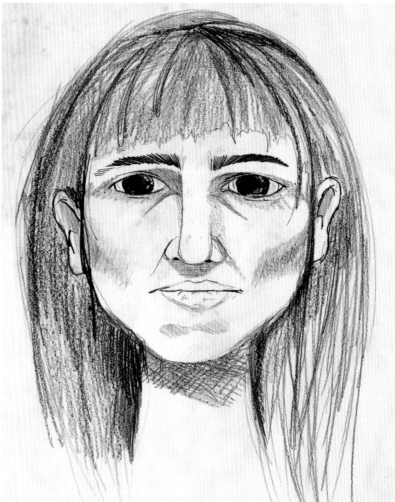
4.

Other Exercises to Try

→ Allow each person to use any medium he or she chooses in making the shared drawing.

→ Make the subject of the drawing a purely abstract composition, using improvised shapes, colors, and textures in any chosen medium.

→ Trade sketchbooks with a partner, and make new sketches in that book that expand on ideas you see suggested by your partner's notations.

GROUP SNAPSHOTS:
EXPRESSING THE GROUP OR CLASS IDENTITY

The idea of the group snapshot is to create a large-scale image that expresses the group's identity. The basic approach is to create a montage of silhouettes drawn by each member of the group on a large piece of paper, and then to work into these tracings with paint and collage in order to create a group portrait mural.

Materials

→ Depending on the size of the group, you may be able to fit an entire class on a roll of commercial backdrop paper, which comes in rolls as tall as 14 feet and as long as 50 feet. Less expensive alternatives include "building paper," which comes in 36-inch × 100-foot rolls, or using black tar paper (used for roofing), which you can get at a lumberyard.

→ Each person may choose any drawing or painting medium, including charcoal, pencils, pens, markers, crayons, tempera paint, etc.

Exercise 1. From the Outer Shell to the Inner Circle
The first task is to pair up individuals to trace each other's outlines on the paper.

Each person takes a turn lying down on the paper in a pose and having his or her partner draw around him or her with a marker or charcoal. These outlined figures may overlap one another, intertwine, and move in all directions. Members of the group may also make more than one silhouette of themselves if they so choose.

The next stage is for each member of the group to draw and paint back into his or her own silhouette using colors, shapes, and textures in a purely intuitive and expressive manner. The resulting mural is a "group snapshot" representing the diverse personalities of each group member.

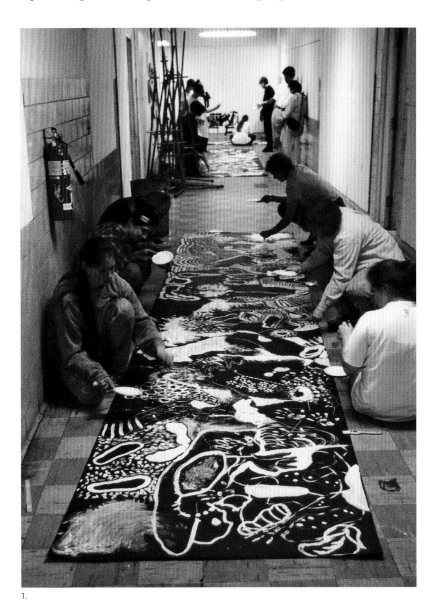

1. Group self-portrait including the silhouettes of twenty-five students.

1.

Exercise 2. Shared Drawing/Shared Creating

Group snapshots may be made using individual sheets of 18 × 24 paper that are arranged in a grid on the floor so that the figure is traced across several sheets. Once all the group members have traced their outlines on paper, the individual sheets are scrambled together and rearranged into a new group portrait composition. This abstract composition can then be worked into with color and texture by the whole group.

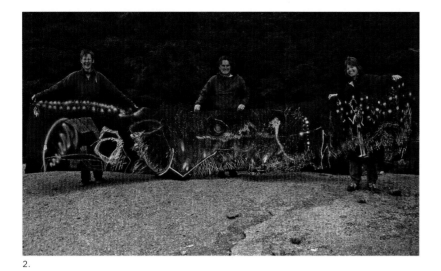

2.

2. Group shared themed drawing on tar paper.

Other Exercises to Try

→ Group snapshot murals can also be made on sidewalks or playground surfaces using colored chalk.

→ The composition of the group snapshot can be varied by changing the arrangement of the figures to take the form of a circle, be aligned in a strict row, and so on.

GROUP SCULPTURE CHALLENGE:
MYTHOLOGICAL 3D CREATIONS

The following exercises move from drawing and painting techniques to sculpture and "installation art" modes. I've included these exercises because they fit in with the shared creation theme and because they strongly encourage group participants to use their instincts and intuition in the creative process.

The central idea of the following exercises is that of creating a sculpture or installation through mutual cooperation and collective interaction, in which each participant plays a role in the outcome. The techniques involved in making this work are low-tech—no special skills are necessary.

Materials

→ Approximately 100–500 pounds of utility clay (depending on the number of people in the group)

→ Plastic drop cloths

→ Cotton or polyester cloth

Exercise 1. Sculpting Gods and Goddesses

A popular theme for this type of sculpture is to create a mythological "god" or "goddess" out of clay, using everyone's ideas, skills, and intuition. To make this project more fun (and to save a lot of clay), one member of the group volunteers to serve as both model and armature and to have the "godlike" features built directly on top of his or her body. Here are the guidelines:

1. This exercise can be done with a minimum of six to a maximum of twenty people, who are subdivided into smaller groups of three or four.
2. The process of creating these mythical figures is as follows: One person in each group volunteers to pose (clothed, of course) for the body that is the base for the sculpture. The volunteer lies on his or her back on a plastic drop cloth while another, breathable cotton or polyester cloth is draped over the model to protect clothes from the stains of the wet clay (although I suggest that the model wear old clothes because it's hard to keep them completely clean).
3. At this point, the other members of the group begin molding the clay into "godlike" forms, which are placed on top of the posed figure to build this fairy-tale personage.

Each group has thirty minutes to create its sculpture and to decide what kind of a god or goddess this figure represents. It could be the "God of Eternal Youth," the "Goddess of Fertility," or anything else the group decides. The challenge is not only to create an innovative sculpture but to explain to the whole group how this fictitious deity came into being and why it is the most powerful god or goddess of them all!

Student posing for *Mythical God* body sculpture.

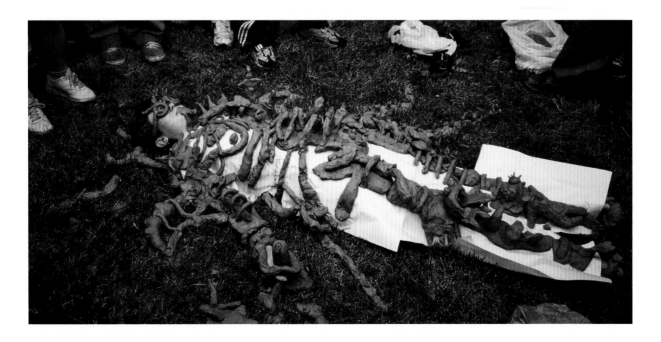

ART FROM INTUITION

Exercise 2. Pass It On

This exercise can be done by giving each person ten pounds of clay to sculpt into a god, goddess, or other creature of their choice. During the process of making these sculptures, each person trades work with someone else in the group until each member has contributed to the final forms of each individual sculpture.

Other Exercises to Try

→ Using the same process as above, try creating a different body form, like an Abominable Snowman, a Cyclops, or a rare animal from science fiction.

→ Use materials other than clay, like papier-mâché or chicken wire, for making the sculpture (not done over a live figure, of course!).

→ Change the location, and use this idea as the basis for a sand sculpture at the beach.

GROUP INSTALLATION ART:
USING YOUR INTUITION TO DRAW IN SPACE

The next exercises challenge participants to work together on installation and environmental artworks that are constructed using simple materials. This process requires everyone to contribute creative ideas.

Materials

→ One bolt of string or twine per student, at least 100 yards long
→ Roll of masking tape (to attach the string to walls, floors, and objects)
→ Scissors

Exercise 1. Doing the "String Thing"

The object of this exercise is to create a string construction that changes the shape and character of an indoor or outdoor environment. To do this, the group uses string as a linear drawing element to reconfigure the internal shapes and external boundaries of a 3D space. Each participant uses a bolt of string and masking tape to create lines extending from the walls, floor, ceiling, and objects in the room or outdoor environment. This 3D "drawing" may be either composed of a completely random arrangement of string lines or organized into geometric forms or regular linear grids that divide the space. This process mimics that of making an automatic drawing, in which you don't plan the composition ahead of time—you just go with the flow. This exercise

can be done by a single group working together in one large space, or smaller groups working in separate parts of the same environment. This exercise also poses interesting questions about the boundaries between 2D drawing and 3D sculpture and opens up possibilities for moving beyond those boundaries in your own work.

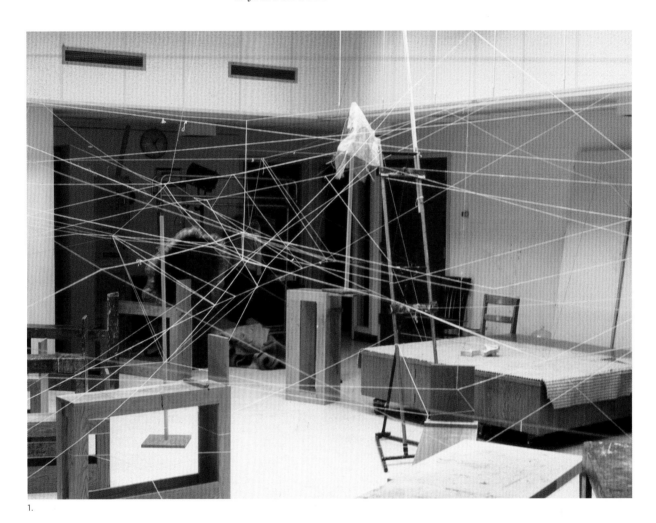

1.

1. Group 3D string installation for an indoor environment.

2. Neon tubes: 3D installation, by Steven Mishol.
3. Student using stretch fabric for a body sculpture performance piece.
4. Wind drawing using Styrofoam packing materials.
5-6. Group drawings with beach stones.
7. Group environmental sculpture, netting and tree trunk, approximately 40 × 40 feet.

Exercise 2. Projects in an Outdoor Environment

The illustrations shown here are environmental sculptures that were made by students from the Massachusetts College of Art (Boston) and were created at the Haystack Mountain School located in Deer Isle, Maine. Some of these projects included creating wind sculptures using lightweight foam materials, composing neon tubes as an interactive "drawing" within the environment, and composing natural elements with man-made materials as a mixed-media sculpture. This group environmental art excursion has been going on for over twenty years, and it has proven to be a very effective way of motivating art students to think beyond the borders of the picture frame, and to use their powers of intuition to the fullest extent.

2.

3.

4.

5.

6.

7.

Other Exercises to Try

→ Use fabric instead of string to modify an environment.

Artists on Intuition "I think of my creative process as a conversation. I work on two or three paintings at once; they are all hanging on nails on a drip-stained wall in my studio. I generally don't work from sketches or any preconceived ideas of what the piece will look like when it's done. Instead, I often start by adding layers, washes, bits of paper, or writing—anything to just start the conversation. I will keep adding layers, covering them up and trying to reveal them again. If I feel unsure of where to go next, I sit in a chair across the room and just look at the work. I look and I wait until I feel my intuition stir somewhere in my solar plexus. Some people call this a 'gut feeling.' It's reassuring to know there is always this internal way of knowing to have as a creative ally." Cheryl Warrick

Stick With It!
WITH A LITTLE HELP FROM MY FRIENDS— DISCUSSING YOUR ART WITH OTHERS

As we all know, it is often difficult to see our own work objectively, and there are times when our perspective on our art could benefit from the fresh viewpoints of others. One of the biggest problems for many artists is that they don't have access to people who can offer them criticism and advice or act as a sounding board for new ideas. To combat this problem, I recommend that you start an art discussion group. This will give you an opportunity for regular dialogue with other artists and creative people that can help sustain your own art-making processes.

GETTING STARTED WITH PARTNERS-IN-ART SESSIONS

Find one or more people interested in being partners-in-art. The individuals you gather together for discussion sessions need not be artists themselves, or even artists who work in the same medium as do you. If you don't know anyone who fits the bill as a partner-in-art, I suggest running a small ad in a local newspaper or printing up your own fliers, which you can post around town.

Plan to meet once a month. Find a day and time that can accommodate everyone's schedule—and then stick to it. If you are meeting as a group of three or more people, you can decide to take turns being the focus of the discussion and rotate the meeting place among the group members' residences.

Have an open dialogue. The spirit of the partners-in-art meetings should be that of an open and broadly based dialogue about one another's art and the creative process, rather than a formal critique wherein the merits of what is good or not so good about a particular piece of art are debated.

Make art together with your partners-in-art. Plan some communal art-making sessions with your partners-in-art group using the art games that are suggested in the next chapter. Or, work together on projects like Out of the Shadows or Gesture Drawing, which can be set up for two or more participants.

It's All in the Game: Using Your Creativity as You Play

Drawing games are a fun way to ignite your intuition and imagination. I've used the games in this chapter with my drawing classes as a way of sparking the kind of raw creativity that is needed to compete. Of course, my secret agenda is to get everyone to use their intuition and sense of invention as they play. A nice feature of these games is that there are no qualifications for playing, and they are accessible to all age groups—from kids to adults—and benefit artists and nonartists alike.

The following art games can be played by two or more people in a small, informal gathering or used as a group project in an organized art class. Although these games do not emphasize the importance of winning, you may want, just for fun, to offer some off-beat, comical prizes, such as a bag of Tootsie Rolls or a $2 gift certificate to a local coffee shop. The rules of any game can be changed to make it more interesting to the group you are working with; or, you can just make up your own rules as you go along!

SAVE THE FUZZY CREATURE:
PROTECTING THE CUTE FUR-BALL
FROM THE EVIL GRIM REAPER

Save the Fuzzy Creature is a drawing game that was invented by Professor Chuck Stigliano, a colleague of mine at the Massachusetts College of Art in Boston. This game reflects Chuck's wit and marvelous sense of humor, and it is one of the most popular drawing games I've used in my classes and workshops over the years.

Materials

→ 18 × 24 newsprint or bond paper
→ Any drawing or painting medium of your choice

Exercise. The Battle Is On!

The object of this game is to decide the fate of a Fuzzy Creature (e.g., a baby bunny) that is being alternately attacked and defended by two opposing players. The person who draws the Fuzzy Creature is its defender, and the other person plays the role of the Grim Reaper, who is trying to hasten the demise of this too-cute cartoon character. All the attacks and defenses are drawn on one piece of paper with each player taking a turn at being on the offense or defense. The rules for playing the game are as follows:

1. You may use an attack or defense *only once* during the game.
2. An attack or defense may use words but must also include drawing.
3. Each player has a maximum of three minutes to complete his or her turn.
4. The Fuzzy Creature cannot die in an attack by the Grim Reaper until the Protector has had an opportunity to defend against the attack. In other words, an attack may touch the contour of the Fuzzy Creature but may not kill it in the same turn.
5. Only the Protector may draw on the Fuzzy Creature itself.
6. You may relocate the Fuzzy Creature somewhere else on the paper only once.
7. No player may declare, "I decree the Fuzzy Creature to be dead! Duh!"
8. The game is over, and a winner declared, when the Grim Reaper can't think of another attack to do away with the Fuzzy Creature, or when the person protecting the creature runs out of ways of defending it.

Save the Fuzzy Creature drawing, ink, markers, and pencil on paper.

Other Exercises to Try

→ Play this game so that the fate of the Fuzzy Creature has to be decided within a strict time limit of thirty minutes. If the reaper fails to do his job within the preset time limit, the Fuzzy Creature may live on forever!

SILENT COMMUNICATION:
SPEAKING IN MARKS, SHAPES, AND COLORS

Like Save the Fuzzy Creature, Silent Communication is a game played between two people who are drawing directly in response to one another. The object of this game is for the two individuals to visually communicate with each other by drawing marks, textures, and colors on paper without the benefit of any vocal, written, or symbolic messages. In the context of this game, the word *communicate* means that the partners are signaling to one another a series of raw emotions and energy in a purely visual way, without having a literal story to tell.

1. Partners Lucille Stein and Meesook Choe work on a project together.
2. Silent Communication drawing expanded into a complete composition, mixed media on paper.
3. Silent Communication drawing expanded into a complete composition, mixed media on paper

Materials

→ 18 × 24 newsprint or bond paper
→ Any drawing or painting medium of your choice

1.

Exercise 1. Don't Talk—Draw!

Try to communicate your emotions to your partner using only marks, colors, and brushstrokes. In other words, you may express one kind of emotion by making aggressively bold marks in charcoal, another by using a delicate mark that's speeding along toward the edges of the paper, and yet another that may zoom up and down the page abruptly. The point of this game is to try to express a series of contrasting emotions that will elicit a similar (or opposite) response from your partner. Keep in mind that you are not trying to figure out what your partner is literally "saying," but are simply responding to what you see happening in his or her drawing. There is no way to predict how these drawings will look at the end of your session, and that's what makes this game so much fun to play!

2.

3.

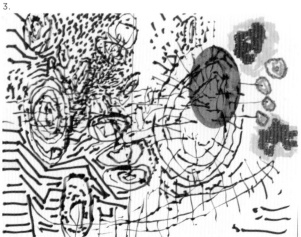

Here are the rules:

1. Remember the "Don't Think!" rule in this game? Simply respond visually and directly to the marks, colors, and textures your partner is drawing.
2. Partners should face each other across a table and draw onto separate pieces of equally sized paper.
3. One person agrees to initiate the Silent Communication by drawing some lines, textures, or colors onto paper for the partner to respond to.
4. The other partner begins to respond to these visual elements within thirty seconds of when the last marks were made.
5. No talking is allowed between the partners.
6. Do not look at each other during the game—you must keep your attention on your partner's drawing and not on his or her facial expressions.
7. You may not use any text, phrases, or visual symbols, i.e., no drawing an object like a stick figure, cloud, sailboat, etc.; nor may you use a common symbol like an arrow, a dollar sign, a peace symbol, and so on.

Exercise 2. So What Are You Drawing About?

In this version of Silent Communication, the first person to draw decides on a mystery topic or theme that the partner will then try to guess. The person drawing the theme gives his or her partner visual clues about the theme, and the partner makes guesses using visual means, trying to name this theme. The same rules apply as above, including the stipulations that there be no talking and no use of written words in the drawing itself. The exception to the rules is that both players may draw arrows, question marks, and exclamation points on their drawings to help guide their partner. This game is similar to the popular game Pictionary, except that all the questions and responses are contained within a drawing.

4-5. Silent Communication drawing in progress, Charlie Braun and Miles Johnson.
6. Silent Communication drawing in progress, Victoria Jacobs and Meesook Choe.

4.

5.

6.

Other Exercises to Try

➜ Another variation is to use only geometric and free-form shapes and symbols for the Silent Communication.

➜ Instead of drawings, have the communication take the form of spontaneous writing, in which both players are writing in a stream-of-consciousness fashion on a given topic without looking at what their partner is writing.

DRAW THE MYSTERY OBJECT:
DRAWING A CONCEALED OBJECT USING ONLY YOUR SENSE OF TOUCH

The goal of this game is to draw an object that is concealed from sight by using only your sense of touch. The game starts with your partner or group leader finding a mystery object—one that is difficult to figure out only by the sense of touch—and hiding it from sight in a bag or box. The person who draws the most accurate version of the hidden object wins the game.

Silent communication, smooth versus textured.

One of the biggest challenges of this game is for someone to find a mystery object that is difficult to figure out only by one's sense of touch. The ideal type of object is a small to medium-sized article that has complex or unusual surfaces that someone would have trouble identifying by touch alone. Such an object may be something like an antique tool that makes one wonder, "What the heck was that used for?" or an unusual object that you'd find at a flea market or secondhand store like an oddly shaped toy, a weird bottle, or some odd kitchen gadget. Keep in mind that this object can't have any sharp surfaces that might cut someone while feeling it.

A nice feature of this game is that kids as young as five years old can play along with adults of any age, and no prior art experience is needed in order to play. This game can be really interesting to play with groups of ten or more people, as the more people that play the more bizarre the variety of responses you'll see.

Materials

→ The mystery object
→ An opaque cloth or paper bag in which to hide the object
→ 18 × 24 newsprint or bond paper
→ Simple piece of charcoal, an Ebony pencil or a marker pen
→ Prizes for the winning drawings

Exercise 1. So, What Is This, Anyway?

Conceal the mystery object by putting it inside an opaque cloth or paper bag. Once the object is hidden, get each player to reach inside the bag and touch the object for a maximum of fifteen seconds, after which they draw the shape of the object as accurately as possible based strictly on their sense of touch. The person who draws the most accurate version of the hidden object is the "winner" of the game. The winner is decided by a group vote after everyone sees what the actual object looks like. Another, more interesting, option is for the group to vote for the most accurate drawing *before* they see what it looks like. That way, everyone is going strictly by their sense of touch and not simply voting for the most obvious likeness. In a large group or class situation, you may want to have multiple winning illustrations, including "The Most Inventive Solution," "The Most Off-base Solution," or "The Most Outrageous Solution." I like to give a special award to anyone who is psychic enough (a "Master of Intuition") to guess what color the object is before they see it.

As for the prizes for the winners, I recommend something like a nice, chocolate candy bar or an inexpensive tube of paint, an artist's brush or a pad of drawing paper.

Exercise 2. Make Your Own Secret Object

A simple way to make your own secret object is to crumple a piece of paper into a random shape or to mold a small chunk of clay into a nondescript form to use as the mystery object.

1. The mystery object is a teapot shaped like a dog.
2. A Mystery Object contestant feels the concealed dog teapot.
3. Four winning drawings of the dog teapot.

1.

2.

3.

Other Exercises to Try

→ Draw the Mystery Object can be played with a partner and someone serving as a timekeeper and judge. In this version, each partner feels the object and draws it at the same time. The contest begins after both artists have had fifteen seconds to touch the object and then two minutes to finish their drawings. As above, the drawing that best resembles the object wins as determined by the third-party judge.

→ Partner teams can also play this game where one partner feels the actual object and then verbally describes what the object felt like to his or her partner. The second partner must then draw the object based solely on that verbal description alone. The team that makes the most accurate drawing of the mystery object wins the candy bar!

4. Suk Shuglie celebrates the joys of creating.

4.

Artists on Intuition "My intuitive process is elastic, nonlinear, needs to meander, gathers randomly, and feels its way through trial and error, and is therefore an elaborate, groping form of play. Working quickly bypasses self-consciousness, premature judgments, and mediated choices that are too cautious. The goal of my approach to painting is to touch as much information as possible, all the while feeding my intuition so that I can feel the patterns that are layered beyond the confines of my everyday life." Larry Hayden

Opposite page: *Banner 8*, mixed media on canvas, by Larry Hayden.

Stick With It!
NOTHING CAN STOP YOU NOW

I hope that by now I've got you hooked on the idea of making art as a valuable, ongoing part of your creative life. So let me review the factors that will help you continue to stay focused on your art and not let it fall by the wayside.

1. Reread the "Top Ten Obstacles to Making Art" from Chapter 1, and promise yourself that you won't fall victim to the pitfalls and fears they describe.

2. Do the exercises in this book to get you started on new ideas and to help you keep going forward with your artwork.

3. Use your sketchbook and To Be Continued, Like, and Dislike portfolios to build up your reserves of ideas for future work that will help sustain your interest in making art.

4. Continually challenge yourself to explore new territory in your art so as to avoid getting in the rut of making only pictures that fit into your comfort zone.

5. Attend art classes and art exhibitions to keep yourself inspired.

6. Make use of the self-critique process to step back and look objectively at your work on a regular basis.

7. Form a partners-in-art group, and meet with them at least once per month.

8. Don't get lazy and let your creative life slip away just because you feel blocked. Instead, learn how to work through these phases.

9. Always make art *for yourself*. No one ever knows what type of art will sell or be popular, so set aside these notions and allow yourself to create freely.

10. As I've said from the beginning— "Invite your intuition to be your trusted guide in art." And, "Don't think—*do*!"

Blue Fez, oil on linen, by Fred Lange.

Acknowledgments

I wish to acknowledge the following individuals and institutions for making this book possible. My utmost appreciation goes to my lifelong friend Gregory Amenoff for writing his intelligent and perceptive Foreword for this book. I would also like to thank my close friend Jane Davies for inspiring me to write this book in the first place, and for introducing me to Senior Editor Joy Aquilino at Watson-Guptill.

I am particularly indebted to two people who were key figures in helping me write this book. First, I want to express my deep appreciation to Christopher Willingham for his substantial contributions to this publication. Chris, a highly talented artist and innovative teacher in his own right, signed on at the beginning of this project to help me develop the core ideas and hands-on projects that are the backbone of this book. Working with me for long hours over a two-year period, Chris was there to contribute his insights and expertise, and to be a consummate sounding board for the goal of "getting it right." Chris also contributed many illustrations for the book, including his unique and beautiful candle smoke and charcoal paintings.

Christopher Willingham

The second key person I wish to acknowledge is Angela McGuire, my studio assistant and all-around go-to kid, for her help in keeping me organized and on track to finish this task on time. In addition, Angela contributed several wonderful examples of the projects that are distributed thoughout the book—not bad for someone who has only one drawing class in her newfound art career! As for bragging rights, Angela continues to advance in her artwork, as she has received a four-year scholarship to the Massachusetts College of Art in Boston—way to go, Angela!

I want to especially thank Joy Aquilino, Senior Acquisitions Editor at Watson-Guptill, first for recognizing the potential of my book, and then for shepherding its publication through the maze of obstacles on the way to bring-

Angela McGuire

ing it to fruition. In addition, I want to bestow high praise and laurel wreaths upon my editor, Cathy Hennessy, for her wholehearted enthusiasm in giving shape to the book and for her kind patience in response to my inability to meet certain important deadlines. Cathy brought her unique insights and intelligence to refining both the design and the content of *Art from Intuition*, and I feel honored to have had her as a partner in the most difficult and important stages of the book's development.

I wish to acknowledge Rodrigo Corral for the book's cover design, Jason Ramirez for the design of the interior, and Timothy Hsu for his art direction. Many thanks also go to William Alatalo, Antonio Costa, and Bronwin Hodgkinson of cdeVision multimedia designers for providing much technical assistance for the book. I highly recommend cdeVision as website designers—they made my site, and I think that they are terrific!

I also wish to thank the following artists, friends, and family members who contributed their time, energy, and artworks to *Art from Intuition*:

Mathew Allen, Sara Amos, Adria Arch, Charlie Braun, John Calhoun, Luke Cavagnac, Meesook Choe, Frank Cressotti, Jane Davies, Jim and Bev Davies, Stuart Diamond, Robin Eldridge, Carlos Estevez, Danielle Federa, Deborah Ford, Sonia Gurewitsch, Gary Hallgren, Larry Hayden, Alix Hegeler, Mark Kelly, Jeff Keough, Fred Lang, Paul Leveille, Amy MacDonald, Velma J. Magill, Kristen Mills, Rob Moore, Bill Myers, Christina Newman, Corey Nimmer, Lilly Nimmer, Frank Ozeriko, John Polak, David Prifti, John Ramondi, Mo Ringey (the "cover girl" appearing on the book jacket), Linda Ross, Sunne Savage, Monroe Schwenk, Suk Shuglie, Gene and Kathy Sizemore, Leslie Smith, Madeleine Soloway, Alex Thurman, Tomas Vu, Kanji Wakae, Cheryl Warrick, Christopher Willingham, and Yuriko Yamaguchi.

I further wish to acknowledge the students, past and present, who contributed artworks to this publication:

Amanda Accardi, Bonnie Acker, Nancy Adams, G. Angell, Aryn Banas, Trevor Banas, Chong Bang, Michelle Baroff, Jasmine Baxter, Anne Marie Belden, Scott Beluzo, Susan H. Benford, Dan Bennette, Susan Blatt, Alexandra Brault, Meghan Brault, Pauline Briere, Eduardo Caminos, Catherine V. Carija, Greg Charbonneau, Denise Collins, Sharon Daires, Julia Dalton, Theresa Davenport, Noelle Delaicu, Annette Diapolo, Meg Donabediar, Adell Donaghue, Brenda Doucette, Juave Duval, Vivienne Frachtenberg, Mike Frazier, Abbie Germain, Steve Gildea, Yuette Gonzalez, T. Gorman, Marsha Grant, Bill Griffin, Delphine Herman, Liz Hardy Jackson, Liz Jacobs, Cole Johnson, Miles Johnson, Paul Patrick Joyce, Mark Kasianovirg, Kim Katz, Susan Lesburg, Lin Li, Jennifer Loglsci, Marie Maguire, Yubica Mahovecka, Aimee Mathers, Angela McGuire,

Linda McManus, Bruce Minko, Jeremy Miranda, Bessie Moulton, Claire Noonan, Marie O'Neill, Lisa Osborn, Kurt Pepondolo, Nicole Perry, Scott Polley, Susan Pourgan, Ryan Rege, Elizabeth Rostron, Brenda Salisbury, Anna Seney, Elaine Shannon, Laura Shinopidos, Kevin Smith, Ryan Smith, Lucille Stein, Jeanne Strealewicz, Carol Strute, Danielle Tebo, Gerry Tuten, Ahea Wallace, Ethan Weiheiner, Patricia Weisberg, Christine Wessig, Anne Chris Western, Marsha Wiggins, Tom Wong, Matthew Yee, and Kristin Zottoli.

Finally, I am most grateful to the students, faculty, and staff at the Massachusetts College of Art in Boston; Holyoke Community College, Holyoke, Massachusetts; and the Central Academy of Art and Design in Beijing, China, for the privilege of being associated with these fine educational institutions. Teaching there has added to the depth, quality, and vitality of my life and my art, and the substance of this book was based upon my rewarding experiences of teaching art to over 9,000 students and counting.

Studio of Intuition, by Paul Leveille.

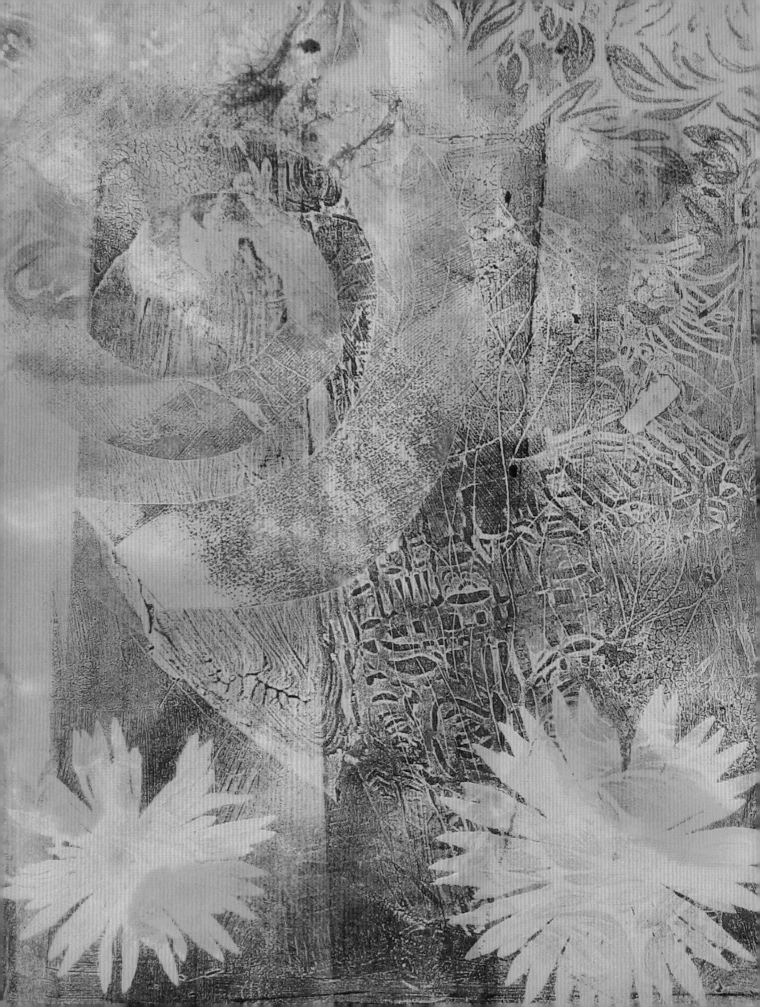

Resources for Artists

Keeping your art practice alive and well on your own
can be challenging at times. Throughout *Art from Intuition*, I've discussed
the importance of having a partner-in-art and of taking an art class to put
you in touch with fellow artists who share your interests. This advice brings
up the problem of finding individuals, classes, and other resources that you
might not be aware of. Some of this information can be found in your local
and regional art periodicals and community newspapers, bu t the Internet
has the most extensive listing on almost any art-related topic you can think
of. Listed below are some popular websites that can give you a start in mak-
ing connections with artists, art classes, artists' colonies, exhibitions, and
grant programs that could prove to be another important tool in your artist's
survival kit.

Websites for Artists' Colonies and Art Classes

Alliance of Artists Communities

www.artistcommunities.org
Extensive listing of artists' colonies and residency programs across the United States and abroad

Res Artis

www.resartis.org
Worldwide network of artists' residencies and residential art centers

Contact Information of Selected Prominent U.S. Artists' Colonies

Anderson Ranch Arts Center

P.O. Box 5598, Snowmass Village, CO 81615
telephone (970) 923-3181
fax (970) 923-3871
e-mail info@andersonranch.org
www.andersonranch.org

**Appalachian Center for Crafts
(Tennessee Tech University)**

1560 Craft Center Drive, Smithville, TN 37166
telephone (931) 372-3051,
 (615) 597-6801
fax (615) 597-6803
www.tntech.edu/craftcenter

Bemis Center for Contemporary Arts

724 South 12th Street, Omaha, NE 68102
telephone (402) 341-7130
fax (402) 341-9791
e-mail info@bemiscenter.org
www.bemiscenter.org

Fine Arts Work Center in Provincetown

24 Pearl Street, Provincetown, MA 02657
telephone (508) 487-9960
fax (508) 487-8873
e-mail general@fawc.org
www.fawc.org

Haystack Mountain School of Crafts

P.O. Box 518, Deer Isle, ME 04627
telephone (207) 348-2306
fax (207) 348-2307
www.haystack-mtn.org

The MacDowell Colony

100 High Street, Peterborough, NH 03458
telephone (603) 924-3886
fax (603) 924-9142
e-mail info@macdowellcolony.org
www.macdowellcolony.org

Mary Ingraham Bunting Institute

Radcliffe Institute for Advanced Study,
Harvard University
Radcliffe Institute Fellowships Office
34 Concord Avenue, Cambridge, MA 02138
telephone (617) 496-1324
e-mail fellowships@radcliffe.edu
www.radcliffe.edu/fellowships/bunting.php

Mattress Factory, Ltd.

500 Sampsonia Way, Pittsburgh, PA 15212
telephone (412) 231-3169
fax (412) 322-2231
e-mail info@mattress.org
www.mattress.org

Skowhegan School of Painting and Sculpture

www.skowheganart.org

Year-round
200 Park Avenue South, Suite 1116
New York, NY 10003-1503
telephone (212) 529-0505
fax (212) 473-1342
e-mail mail@skowheganart.org

Summer program
P.O. Box 449, Skowhegan, ME 04976
telephone (207) 474-9345

Vermont Studio Center

P.O. Box 613, Johnson, VT 05656
telephone (802) 635-2727
fax (802) 635-2730
e-mail info@vermontstudiocenter.org
www.vermontstudiocenter.org

Women's Studio Workshop
P.O. Box 489, Rosendale, NY 12472
telephone (845) 658-9133
fax (845) 658-9031
e-mail info@wsworkshop.org
www.wsworkshop.org

YWCA—New York City
50 Broadway, 13th Floor, New York, NY 10004
telephone (212) 755-4500
fax (212) 838-1279
e-mail info@ywcanyc.org
www.ywcanyc.org

Websites for Art News, Reviews, Exhibitions, and Grant Opportunities

Art a GoGo
www.artagogo.com
Online newspaper reporting on current exhibits and show opportunities for artists

Art Calendar: The Business Magazine for Visual Artists

www.Artscuttlebutt.com
Website for artists to exchange information about themselves and their art

www.artcalendar.com
Listing of art exhibition and grant opportunities and information on artists' materials

Artist Income and Exhibition Opportunities
www.artdeadline.com
Listing of art exhibition and grant opportunities

World Wide Gateway to the Arts
www.art4net.org
Listings of individual artists, galleries, and art for sale plus other useful resources for artists

Art Network
www.artmarketing.com
Listing of a variety of business resources and grant opportunities for artists

Registry of American Fine Artists
www.artistregistry.com
Listings of individual artists, galleries, and art for sale plus other useful resources for artists

Artist Famous
www.artistfamous.com
Directory of links to artists, exhibition opportunities, and art supply companies

Artnet: The Art World Online
www.artnet.com
Listings of individual artists, galleries, and art for sale plus other useful resources for artists

Arts Journal: the Daily Digest of Arts, Culture and Ideas
www.artsjournal.com
Daily arts listings from more than 100 newspapers, magazines, and online publications

Fine Art Marketplace and Community
www.fine-art.com
Listings of individual artists, galleries, and art for sale plus other useful resources for artists

World Wide Arts Resources
www.wwar.com
Listings of individual artists, galleries, and art for sale plus other useful resources for artists

Widely Distributed Magazines and Newspapers Covering Artists and Art Criticism

American Artist
The Art Bulletin
Art Calendar Magazine
Artforum
Art in America
The Artist's Magazine
Art New England
ARTnews
International Artist
Modern Painters
New American Paintings
The New Yorker
The New York Times, Arts & Leisure

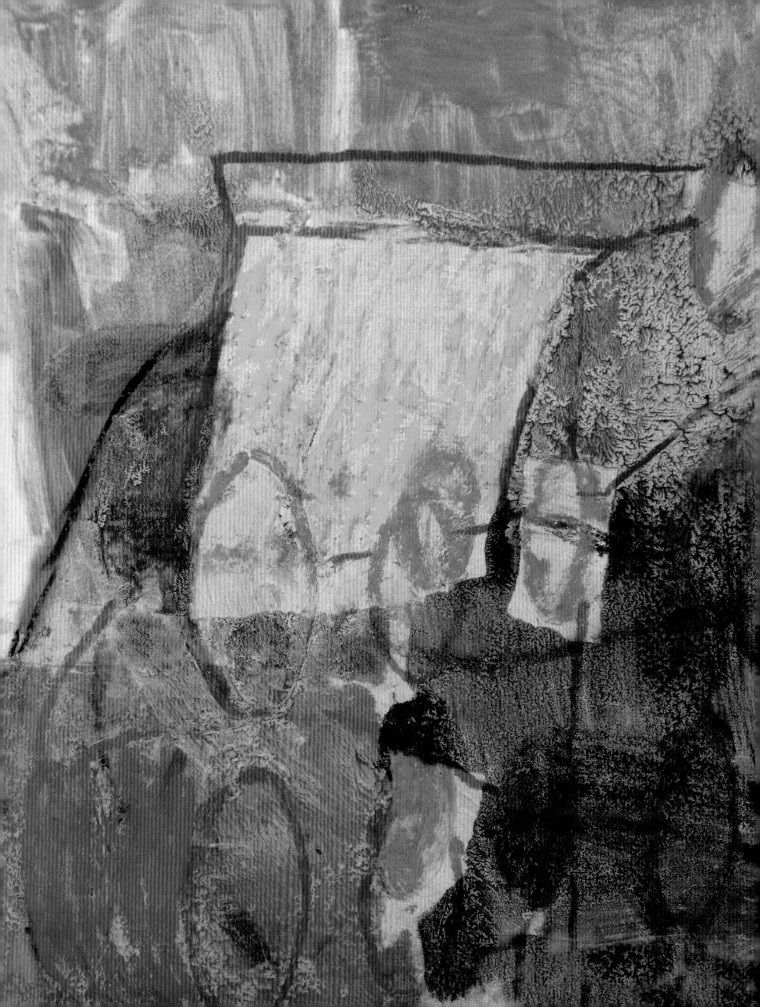

Waterfall, watercolor and pastels on
paper, by Dean Nimmer.

Bibliography

100 Creative Drawing Ideas. Compiled and edited by Anna Held Audette.
　　Boston: Shambhala Publications, 2004.

A Book of Surrealist Games. Compiled by Alastair Brotchie and edited by
　　Mel Gooding. Boston: Shambhala Publications, 1995.

Allen, Pat B. *Art Is a Way of Knowing.* Boston: Shambhala Publications, 1995.

Ayres, Julia. *Monotype: Mediums and Methods for Painterly Printmaking.*
　　New York: Watson-Guptill Publications, 1991.

Bayles, David, and Ted Orland. *Art & Fear: Observations on the Perils
　　and Rewards of Artmaking.* Saint Paul, MN: The Image Continuum
　　Press, 1993.

Carbonetti, Jeanne. *The Yoga of Drawing: Uniting Body, Mind and Spirit in
　　the Art of Drawing.* New York: Watson-Guptill Publications, 1999.

Compton, Annette Carroll. *Drawing from the Mind, Painting from the Heart.*
　　New York: Watson-Guptill Publications, 2002.

Davies, Jane. *Collage with Color: Create Unique, Expressive Collages in
　　Vibrant Color.* New York: Watson-Guptill Publications, 2005.

Edwards, Betty. *Drawing on the Artist Within.* New York: Simon and
　　Schuster, Inc., 1986.

Gladwell, Malcolm. *Blink: The Power of Thinking Without Thinking.*
　　New York: Little, Brown and Co., 2005.

Gold, Aviva, and Elena Oumano. *Painting from the Source: Awakening
　　the Artist's Soul in Everyone.* Spencertown, NY: Source Books, 2002.

Goldberg, Natalie. *Writing Down the Bones: Freeing the Writer Within.* Boston: Shambhala Publications, 1986.

Grey, Alex. *The Mission of Art.* Boston: Shambhala Publications, 2001.

Kaupelis, Robert. *Experimental Drawing.* New York: Watson-Guptill Publications, 1992.

Koren, Leonard. *Wabi-Sabi for Artists, Designers, Poets & Philosophers.* Berkeley: Stone Bridge Press, 1994.

London, Peter. *No More Secondhand Art: Awakening the Artist Within.* Boston: Shambhala Publications, 1989.

Maisel, Eric, Ph.D. *Fearless Creating: A Step-by-Step Guide to Starting and Completing Your Work of Art.* New York: Jeremy P. Tarcher/Putnam, Penguin Putnam Inc., 1995.

Malchiodi, Cathy A. *The Soul's Palette.* Boston: Shambhala Publications, 2002.

Masterfield, Maxine. *Painting the Spirit of Nature.* New York: Watson-Guptill Publications, 1996.

McNiff, Shaun. *Art As Medicine: Creating a Therapy of the Imagination.* Boston: Shambhala Publications, 1992.

———. *Art Heals: How Creativity Cures the Soul.* Boston: Shambhala Publications, 2004.

———. *Trust the Process: An Artist's Guide to Letting Go.* Boston: Shambhala Publications, 1998.

Nachmanovitch, Stephen. *Free-Play: Improvisation in Life and Art.* New York: Jeremy P. Tarcher/Putnam, Penguin Putnam Inc., 1990.

Perry, Vicky. *Abstract Painting: Concepts and Techniques.* New York: Watson-Guptill Publications, 2005.

Prosciutto, Schlomo. *My Love Is a Ham Sandwich and Your Mustard Ain't No Good.* Atlanta: Red Roaster Press, 1968.

Rothko, Mark. *The Artist's Reality: Philosophies of Art.* New Haven: Yale University Press, 2004.

Schwabsky, Barry. *Vitamin P: New Perspectives in Painting.* New York: Phaidon Press Ltd., 2002.

Storr, Robert. *Philip Guston.* New York: Cross River Press Ltd. Abbeville Publishing Group, 1986.

Index